SANAA in Sydney

SANAA in Sydney

The architecture of Naala Badu at the
Art Gallery of New South Wales

Edited by
Michael Brand

Photography by
Iwan Baan

The Art Gallery of New South Wales acknowledges the Gadigal of the Eora nation, the traditional custodians of the Country on which it stands in Sydney.

The new Art Gallery building designed by SANAA has received the Aboriginal name Naala Badu, meaning 'seeing waters' in the Sydney language. The original Art Gallery building has received the name Naala Nura, meaning 'seeing Country'. These new names for the two buildings draw on both their architecture and their location on Gadigal Country.

Contents

Architects' statement

Kazuyo Sejima + Ryue Nishizawa / SANAA

Aerial view of Naala Badu, July 2024

Architecture grows and expands with time. It also extends and enriches the place where it stands. We learnt this through our involvement with the 21st Century Museum of Contemporary Art, Kanazawa – a building we completed about twenty years ago. Little by little, the museum became connected to the city. One day, the owner of a nearby gallery discovered that he thought of his own space as one of the exhibition rooms of the 21st Century Museum of Contemporary Art, one that had flown from the museum into the city. The plan of our museum encouraged this perspective, creating a new network between the architecture and its surroundings. Despite this potential of the typology, the museum's glass facade was still a strong boundary. Even if architecture itself is immobile, we began to think about how it could be more physically continuous with its environment. This is something we hope to have achieved for the Sydney Modern Project at the Art Gallery of New South Wales.

One of the ideas we explored in our design for the new building in Sydney was how to create a building from two distinct elements: roofs and boxes. Until this point, we had thought about boxes and about roofs, of course, but there was always a master-servant relationship between them. This method of treating the roof and the box as equals emerged from several characteristics of this particular project.

First of all, the brief asked for both an extension to the Art Gallery of New South Wales and a masterplan for the campus expansion and transformation, known as the Sydney Modern Project. From the very beginning this invited us to think of the architecture as a framework for relationships between a wide range of external spaces and existing museum buildings. The site itself is adjacent to the Royal Botanic Garden that extends across to the headland it shares with the Sydney Opera House, connecting the business district with the residential area of Woolloomooloo. The idea

Ryue Nishizawa and Kazuyo Sejima in Naala Badu

Architects' statement

was that the Art Gallery's masterplan would eventually integrate a library and research centres, creating a larger cultural precinct.

Secondly, the site itself had a unique character. Most of it was not ground as such – there was little natural earth. Instead, it was a terrain where civil engineering structures covered most of the site, symbols of Sydney's modernisation: retaining walls, a land bridge that extends over an expressway, two oil tanks for refuelling ships during the Second World War. Designing on top of these structures gave us the impression we were adding an extra volume to an existing building, rather than constructing a new one. We wanted visitors themselves to experience these existing layers and to engage with this artificial landscape. While various architectural typologies could have done this, rather than introducing a singular tall building with a small footprint that avoided the infrastructure, we developed a form that extended across the complex terrain.

To begin with, we positioned a glass roof over the land bridge at the top of the site. It already served as an open green space and was used by commuters crossing from Woolloomooloo to the business district. By introducing a transparent canopy without walls, it could continue to be used in this way, while also becoming an entrance plaza to the museum, one that would connect the old galleries to the new.

Adjacent to this we placed another roof and a large box, an open entrance hall and an exhibition space. The Entrance Pavilion offers views across the harbour, the Royal Botanic Garden, the Domain parkland, and the original gallery building: it's a space where you can feel the charm of the surrounding topography. Further down the terrain we found several strips of flat land, created by retaining walls and the existing oil tanks. On the first terrace, 6 metres below the Entrance Pavilion, we built a second gallery and a roof that defines the cafe. It is a space where visitors can feel the scale of

Kazuyo Sejima + Ryue Nishizawa

civil engineering. Six metres below this, we found another sizeable flat area, a green space that sits above the historic oil tanks. Here we introduced a third exhibition volume and a multipurpose room where, like on the floor above, the retaining walls cross through the building itself. Beneath this, the oil tank itself is reimagined as an exhibition space. From the top of the hill to the oil tank at the bottom, visitors experience both the strata of the site and a gallery at each level. They are invited to enjoy the museum as inextricable from the hill, park and harbour views.

Circulation weaves between these three main gallery volumes. It becomes a foyer where you can rest, a space where you can feel the topography, and an extension of the exhibition spaces themselves. By using overlapping roofs to create this route, it became open and continuous. The first pavilion and entrance hall face the road, the second pavilion on the lower level overlooks the harbour, and the third pavilion runs parallel to the road along the bay. The boxes face different directions, creating an irregular space between them. This amoeba-like condition, formed by the three galleries and four roofs, creates a space of soft boundaries that straddles the steps of the topography. We wanted it to resemble an external space, so the walls of the gallery boxes are clad with stones that echo those of the city, the retaining walls are made of rammed earth, and the concrete floor takes on the colour of the soil.

Above this in-between space is a habitable outdoor landscape. The top of the gallery boxes and roofs become terraces and gardens, connecting the roof of the former oil tanks to the land bridge. You may be walking under a roof or a box, or you might be inside a box, but you can always step outside and walk above it, across a rooftop or along narrow planted paths that dissolve into the Botanic Garden. The experience of walking through the site, within the architecture and across the neighbourhood is continuous:

Architects' statement

we hope it becomes difficult to understand where the building begins and where the context ends.

One of the last characteristics to identify the new Sydney building was its scale. Even though its volume is extensive, we didn't want it to overwhelm its surroundings; we wanted instead to make the history of the site tangible. As the design evolved and was gradually simplified, each part grew larger in scale. The project became less like architecture and more like landscape.

At first, we used the words 'box' and 'roof', but these definitions become blurred within the project: the land bridge is also a large roof over a highway and the box that served as an oil tank looks like ground. By searching for a continuous architecture that responds to its environment, we created an even larger box and roof, going beyond the architectural language we have used so far. We hope we are getting closer to an approach that is more environmental than it is architectural, a landscape that offers visitors the freedom to engage with it in many different ways.

Kazuyo Sejima + Ryue Nishizawa

建築が時間と共に育てられひろがっていく、或いは、建築がそのたつ場所をひろげて豊かにしていく。約20年前につくった金沢21世紀美術館にその後も関わりながら、それを教えられた。美術館は少しずつ街につながっていった。ある時、街のギャラリーのオーナーが自分のギャラリーは金沢21世紀美術館の展示室が一つ街に飛んできたものと考えられるという発見をしてくれた。金沢21世紀美術館の平面はそういう視点を生み出し、その視点は建築と街との新しいネットワークを作った。その平面形式は、街と関係をつくれるものであったと思う。しかし同時に、建築がもっと物理的に街に連続できるはずだとも思った。金沢のガラスのファサードは独立性が強い。それではどうやったら建築を周りの環境とより具体的な関係を持つものにできるのだろうかと考えるようになった。建築は基本的には動かないものだが、どういう建築が育てられ広がっていく可能性を持てるか、その後のプロジェクトで考えはじめた。

シドニーのプロジェクトで、私たちが試みたことのひとつとして、屋根と箱の二つから建築を作るということがある。これまで建築を開こうとして、箱について考えたり、屋根について考えたりしたが、その間には主従関係があった。屋根と箱の2つを対等に扱って作っていくというやり方は、今回のプロジェクトのいくつかの特徴から導き出されたと思う。

まず今回の計画の大きな特徴の第一は、この計画が単にニューサウスウエールズ州立美術館の増築計画として新しい美術館を作るというだけではなく、シドニーモダンという、このエリア全体のランドスケープを含むマスタープランや、既存の美術館のプログラム再編成、組み替えなどを含む大きな規模の計画の一部として始まったことだ。つまりこのプロジェクトは、最初の段階からすでに、広い範囲の外部空間と既存の美術館との関係を考えざるを得ないような枠組みの中にあった。建築物だけを設計するというより、いろいろなものとの関係からこの美術館の内容が決まるというところがあった。
対象エリアは、シドニーオペラハウスの岬に広がるボタニカルガーデンに隣接し、ボタニカルガーデンの向こう側の超高層ビルのオフィス街と、眼下に広がるウルムル湾とそのまわりの住宅地をつなぐエリアである。その中に新旧の美術館を使いながら、ライブラリー、リサーチセンターなどが新設され、より大きな文化ゾーンが生まれる。

二つ目の特徴は、計画の敷地のユニークさである。敷地のほとんどがいわゆる地面ではなく、つまり自然の土の大地ではなく、既存の土木構築物が敷地の過半に残存する土地であった。つまり敷地内に、高速道路の上をふさぐランドブリッジと呼ばれる人工地盤、ウルムル湾沿いに遺された第二次世界大戦時の給油用オイル貯蔵タンク、また急傾斜を造成した土圧壁等が敷地内にあり、いわゆる自然の土地は小さかった。そういう複数の土木構築物の上に建築を作るということは、新しく建てるというよりは、いわば既存のビルにもう一部屋付け加えるような、そんなイメージすら感じるような状況であった。敷地に残存するこれらの土木構築物群、ランドブリッジやオイルタンク、土圧壁などは、すべてシドニーの近代化の過程で作られてきたものであり、ある意味でシドニーの近代化を象徴する歴史的・文化的地盤ともいえるものである。そういう上にたてるということはそのまま、シドニー或いはこの地域一帯の時間につながっていくたて方なのではないかと考えた。そこで、それらを最大限そのままの姿で残し、ここを訪れる人々がそれらを最大限経験できるように、人々と地形との対話ができる場所を作りたいと考えた。いろいろな建て方が可能な中で、私たちはそれらの土木構築物を避けて一ヶ所に小さく高く建物を集中的に建てるというやり方でなく、複雑な地形全体に広がるような建築の形を模索した。

まず一番上のランドブリッジの上に、ガラスの屋根をかけた。このランドブリッジの人工地盤は高速の屋根でありつつ、ウルムル湾の通勤客がビジネス街まで通り抜けてゆく際に通過動線として利用してきた公園でもある。そこで私たちは、ここに壁のない透明な屋根を架けることで、この場所を新旧の美術館をつなぐ美術館の玄関広場でもあり、また同時に24時間開放された、人々が通り抜けてゆける公共空間とした。

Architects' statement

このガラス屋根の横に、もう一つの屋根と大きな箱を置いて、屋根のほうを開放的なエントランスホールとして、箱のほうを展示空間とした。この開放的なエントランスホールは、湾やボタニカルガーデン、公園、旧館などを見渡すことができる眺めのよい空間で、丘の上という地形の魅力を感じる空間とした。このエントランスホールの一段下、6メートルほど下がったレベルに、土圧壁によって作られた細長い平地があり、そこには2つ目のギャラリーの箱と、カフェのための屋根を架けた。このレベルは土圧壁によって作られた場所であるので、土圧壁が敷地外から建物内を横断して通り抜けてゆく、土木的スケールを感じる空間となっている。そしてさらにその下、もう6メートルくらい降りたところには多少大きな平地があって、これはウルムル湾沿いのオイルタンクの屋上の緑地である。ここには、3つ目のギャラリーの箱と多目的室などを配した。このレベルでもまた土圧壁が外から入り込み、建物を横切ってゆく。海に向けて4つ目の屋根を架け、その周りに小さな庭が広がり、美術館の外を散歩する人の道が入り込む。そして一番下のレベル、ウルムル湾のレベルにはオイルタンクがあり、そこが最下段のギャラリーとなる。人々は、丘の上のギャラリーから最下段のオイルタンクまで、各レベルに設けられたギャラリーを通りながら徐々に降りてきて、丘から湾までの高低差を感じつつ、また丘や公園、海という景色を感じつつ、美術館をめぐる。

3つのギャラリーの箱と箱の間は、動線空間でもあり、休憩できるホワイエでもあり、地形を感じる空間でもあり、たまにアート展示にも使われる自由な場所で、そこを屋根によって作ることで、開放的な空間としている。1番目のギャラリーとエントランスホールは前面道路に正面し、一段下のレベルにある2番目のギャラリーは海を見る方向に向き、そして3つ目のギャラリーは湾沿いの道路と並行な配置となって、各ギャラリーの箱は各々違う向きを向くことになり、さまざまな方向を向く箱の間に、不定形なスペースが生まれる。このアメーバー状の空間は3つのギャラリーの配置と4つの屋根により、地形の段差を跨いでひとつながりの連続空間となっている。そこはより外部的な空間にしようと考えて、ギャラリーの箱の壁を、シドニーでよく見られる外壁の石と近い石で仕上げ、土圧壁を土仕上げとし、床は土を感じるベージュ色のコンクリートとした。
アメーバー状の空間の屋根上は、屋外の回遊空間となっている。ギャラリーの箱の上や、さっきまで屋根だと思っていたところがテラスや庭になり、オイルタンクの屋上レベルからランドブリッジレベルまでの屋外空間が相互につながる。屋根の下や箱の下の空間を歩いたり、箱の中の空間に入ったりしているかと思えば、外に出ることもできて、箱の上の空間を歩いて、屋根上の庭を歩いて、周りに広がっているボタニカルガーデンにまでつながり、敷地全体と建築を散策する連続的な経験をすることができる。建築の周りも地形の段差があり、樹木が植えられて、歩く小道があり、どこまでがこの敷地なのか、何処までが建築の一部なのかわからない状態になると良いなと思っている。

最後の特徴の一つとして、大きなスケールというものがある。大建築であってもその成り立ちがわかるようなものにしたい、触れることのできる建物にしたいと考えて、あまり複雑になるのを避けつつ設計してゆくと、一つ一つの単位のスケールが大きくなっていった。それは、使うということから生まれる小さなスケールから離れ、人のスケールを想像できる建築のスケールから離れて、むしろ風景のスケールに近づいてくるといえるかもしれない。最初に箱と屋根という言葉を使ったが、高速道路にかかる大きな屋根のようなランドブリッジや、大地かと思えるような大きさのオイルタンクの箱、或いは敷地を貫く大きな地形の段差などの、土木スケールがつくりだす環境に呼応し連続する建築を目指すことで、今まで使ってきたような建築言語の箱と屋根からは離れた、さらに大きな箱と屋根が生まれたのでないかと思う。小さなスケールから離れることの可能性は、建築というより、より環境的な、風景を作る要素に近づいていくということがあるような気がする。使い方を建築が決めるというより、いろいろな使い方がありうる自由さがあると良いのではないかと考えている。

First published in Japanese as: Kazuyo Sejima + Ryue Nishizawa / SANAA, 'Art Gallery of New South Wales expansion', *Shinkenchiku*, January 2023

Kazuyo Sejima + Ryue Nishizawa

Foreword

The art museum as landscape

Juhani Pallasmaa

The new extension of the Art Gallery of New South Wales in Sydney presents an entirely new museum concept: the museum as a landscape. Instead of placing the works of art in relatively closed galleries, it relates the exhibition spaces to each other and to the surrounding landscape context. The architectural volumes of the Art Gallery's new building, Naala Badu, that is the centrepiece of its Sydney Modern Project are organised as a stepped, fan-like entity, integrated with the terrain and the landscape, both natural and urban. From above, the constellation of pavilions appears as a set of radiating rectangular volumes and roof plates in a dynamically opening arrangement. The play of floor levels extends from the glass-covered Welcome Plaza, mediating between the Art Gallery's original building and the new, descending gradually down the hillside through four floors to the harbour level.

The immaterial glass facades and the thin dimensions of structural members, as well as the white colour of the structures, are recognisably SANAA architecture, and create an inviting contrast to the sandstone mass of the original classicist building with its Ionic columns and twentieth-century extensions. The new building's floors connect with outdoor terraces and gardens all the way to the level of the street in Woolloomooloo below. The lowest part, a repurposed former navy oil tank dating from the Second World War, terminates the downward movement in a dramatic contrast to the airy galleries. This rough and dark space exudes a sense of history, and its narrowly spaced concrete columns give the space a somewhat Byzantine tone through association with the magnificent underground cisterns of Istanbul. The composition of abstract forms and spaces turns into a rich experiential narrative.

The Entrance Pavilion, as well as the galleries, avoids axialities and monumentality and creates a choreography of informal movements and

atmospheres. The Yiribana Gallery of Aboriginal and Torres Strait Islander art is placed in a respectful and symbolically meaningful manner next to the entrance. A sense of gravity and the dramatic views down the hillside pull visitors down the terraced composition of spaces to the lower levels, following the natural topography of the site. The circulation through the interlocking interior and exterior spaces on various levels is dynamic, and sometimes the visitor may occupy simultaneously two or three different interlocking spatial units of different heights.

The interaction of the gallery volumes, the merging of architecture, terraces, gardens and planted roofs, make one think of the Hanging Gardens of Semiramis, one of the Seven Wonders of the Ancient World. Instead of creating the traditional closed fort for art, lit from above, this architecture opens out to the site; it is an energising and interactive, but also relaxed, entity of galleries, walkways, landscapes, terraces and breathtaking views. Some criticisms, of informality and even a lack of order, as well as of the absence of a memorably singular sculptural form – the trademark of many recent museums of contemporary art – may be expected from some visitors.

The past few decades have seen countless new museums arising around the world, and museum buildings have been one of the architectural types that has generated new concepts in architecture. To the jury of the Sydney Modern Project architecture competition, SANAA's project represented a new development in the typology of the art museum, which has developed from the early chambers of curiosities and mansions of wealthy patrons, through the classical and modern museum halls, to all-glass pavilions and, lately, to the ideal of 'the white box'. SANAA's new building for the Art Gallery is a museum concept that goes beyond these typologies as it contextualises art through actively fusing exhibition spaces, outdoor terraces and gardens, works of art, and landscape and city views.

Juhani Pallasmaa

Through the outward thrust of the galleries and dynamic openness of the ensemble, the building invites interaction with the original Art Gallery, the city centre, the Domain and Royal Botanic Garden, and the harbour. This brings to mind a thought-provoking assertion of Maurice Merleau-Ponty, the French philosopher, on the essential relatedness of art: 'We come to see not the work of art, but the world according to the work.'[1] Works of art express primarily the human existence in the world. The new building opens up to the landscape and city in a way that makes us see artworks in a fresh, relational manner: set into dialogue with their settings and histories, as well as with each other. These active relationships and experiences reflect the dynamics of the architectural concept itself.

In most contemporary museums, lighting, both natural and artificial, is a distinct element of the experience; here the design helps to blur the transition between sources of illumination. The rotation of the galleries, the asymmetries caused by their location against the escarpment at the back, and their opening towards the harbour, result in the gradual shifting of the atmosphere from closed to open space. The detailing throughout the project is considerate and elegant, as in SANAA projects generally. Due to the constrained formal expression, the subtle variations in materials, colours and illumination resonate with qualities of the site itself. The monumental, curved rammed-earth wall, crossing the entire length of the structure at the back of the galleries, turns into an associative exhibit that echoes quietly but emotively the terrain in which the gallery is located. The sandy-coloured terraces and accessible roofs with views of the harbour create a relaxed atmosphere. This ambience differs fundamentally from the frequently formal and dark atmosphere of art museums.

The post-industrial Tank creates a mysterious extension in time, imagery and atmosphere. Its roughness, coarse materiality, dark colours

and low illumination give rise to a feeling of strangeness, otherness and weight. It creates a powerful contrast to the lightness of the upper galleries, as if revealing a suppressed unconscious memory. The white circular staircase unites the two worlds in a dramatic manner and even seems to mediate light down into the darkness. The sense of weightlessness of the galleries above finds its dramatic opposite here.

Architecture of our time is frequently seen as too extreme in its focus on concepts and formal languages. Yet, the initially controversial Sydney Opera House has turned into an unquestioned symbol of Sydney. The new building designed by SANAA for the Sydney Modern Project also presents memorable and associative imageries. It is rich in its elegant, multi sensory simplicity and liberatingly embodied encounters, which offer fresh experiences of art in relation to the city beyond. The shared task of art and architecture is to mediate our sense of self in dialogue with our experience of the world.

Juhani Pallasmaa

A future to dream into: a director's view

Michael Brand

A future to dream into

Art museum directors need to be dreamers. They must also channel their imagination along intricate pathways of creative collaboration. Few tasks facing them require more of both qualities than an architectural expansion project. It is then the role of the director to dream a different future for the art museum and lead the process of collectively imagining what it might look like, and how it might work. Only at this point can the actual designing begin. This is the story of how the Art Gallery of New South Wales in Sydney worked with SANAA in Tokyo to imagine and then design and build a new art museum building as the centrepiece of the Sydney Modern Project.[1] Together we created a future to dream into.

The Sydney Modern Project emerged from a three-volume masterplan commissioned from Johnson Pilton Walker in 2008 and completed in 2011 under the leadership of my predecessor, Edmund Capon.[2] The report noted that the Art Gallery was 'not able to adequately respond to the demands of a dynamic and rapidly changing world of art, where technology, varied spaces and building services need a high level of sophistication', and concluded with a justified sense of alarm that 'maintaining the "status quo" ... would more than likely result in a slow death'.[3] The solution proposed in the masterplan was the addition of a new building whose benefits would include a reinforcement of the Art Gallery's connection to city and harbour and the creation of a new meeting place for Sydney, in addition to more flexible spaces in which to display art and stage a broad range of public programs. This was the report I inherited when I became director of the Art Gallery in 2012. But a report is far from a dream. Only the physical reality of the site will start to unlock the imagination.

The recommended site for the new Art Gallery building was immediately to the north of our original building, whose form had already evolved from Walter Liberty Vernon's 1890s design through the 1972 and 1988 expansions by Andrew Andersons and, finally, Richard Johnson's rooftop addition, which had opened in 2003. The selected site slopes down from Art Gallery Road north-east towards the harbour at Woolloomooloo, its footprint consisting mainly of two concrete slabs reflecting two significant moments in Sydney's twentieth-century urban history: the roof of two conjoined naval fuel bunkers whose vast volumes were constructed in 1942 during the Second World War and a land bridge built in 1999 to cover an expressway brutally cut through the Domain in the late 1950s between our building and the oil tanks, and then widened progressively. The site brought with it equal measures of beauty and complexity. It would require architects of the highest creative order to create a seamless experience of art, architecture and landscape (something not possible for most urban art museums) and a vibrant public forum where the full range of visual arts, including film, soundworks and performance, could be experienced.

The year 2012 was a good time to start imagining a new art museum building, with many opportunities to learn from recently completed projects. After the opening of Guggenheim Bilbao in 1997, the first decade of the new century had seen an art museum building boom, starting with the opening of Tate Modern in London (Herzog & de Meuron, 2000), another expansion of MoMA in New York (Yoshio Taniguchi, 2004) and the new 21st Century Museum of Contemporary Art in Kanazawa (SANAA, 2004 – discussed by the museum's director, Yuko Hasegawa, on p 131). Renzo Piano's significant reworking and expansion of the Harvard Art Museums, on whose Visiting Committee I was then sitting, was set to open in June 2013, the same month that Herzog & de Meuron's winning design for M+ in Hong Kong was announced. One immediate learning was that each urban and historical context suggested – or at least allowed – a vastly different architectural solution. Sydney was certainly no Manhattan; going high could be ruled out. My own art museum experience further underscored the potential of our site: each of my previous three directorships in North America had involved architectural projects with significant garden components.[4]

When then board president Steven Lowy and I launched the Sydney Modern Vision in March 2013, it was the first public signal that the Art Gallery was dreaming of expanding, and starting to imagine what a new building might look like. The project name was intended to show we would be approaching the future from our global city with

Aerial view of the Art Gallery of New South Wales at lower left looking towards the Royal Botanic Garden, city and Sydney Harbour, July 2023

Michael Brand

an unashamedly progressive and outward-looking vision. It would be more than just a building expansion; it would be a complete institutional transformation, the creation of a new type of hybrid art museum that recognised that the Art Gallery of New South Wales was neither encyclopaedic nor purely contemporary. We would get to mediate past, present and future somewhere in between. Risks would need to be taken.

The New South Wales state government soon provided funding for an international architecture competition launched in February 2014.[5] The competition brief started with a challenge:

> At our magnificent site in Sydney, where extraordinary natural beauty is overlaid by complex world histories, can we transform our much-loved Art Gallery of New South Wales into a twenty-first-century art museum that inspires both local and international audiences?

The Sydney Modern Project would need to engage with the living heritage of our site on unceded Gadigal Country as well as create a meaningful relationship with the Domain, the parkland precinct in which the Art Gallery is located, the adjacent Royal Botanic Garden, the city's central business district further to the west, and the inner-city residential area of Woolloomooloo below to the east.

* * *

The competition brief called for circulation paths that would enrich visitors' experience of the original and the new buildings, which would be displaying a mix of historical and contemporary art within multiple architectural styles. It required additional space for the display of the Art Gallery's collection and temporary exhibitions as well as creative and social hubs offering opportunities for learning and participation. On the logistical side, we needed a new loading dock and spatial flexibility that would allow for the continuing evolution of art museum practice in the twenty-first century. On the commercial side, we would need spaces to generate additional revenue to support our increasingly ambitious

operations while also enhancing visitor experience. On all fronts, there were both needs and opportunities to embrace the potential of growing digital connectivity.

The signing in late 2014 of Green Protocols by the Bizot Group of leading international art museums was timely, since its slight relaxing of previously rigid requirements for temperature and humidity conditions according to the differing needs of distinct spaces within an art museum allowed us to aim for reduced energy use as part of the highest standards of sustainability.

Our site is unquestionably a spectacular one. However, it included some challenging features, including a drop of 20 metres from the public entrance on Art Gallery Road to the new loading dock on Lincoln Crescent by the Woolloomooloo foreshore. How could we open up our new building to this glorious landscape while respecting Sydney's subtropical climate and sparkling light? The need to provide 24/7 pedestrian access between the city and Woolloomooloo meant the new building could not be directly joined to the original building. The six-lane expressway running under the land bridge precluded a subterranean link between the two buildings.

An architecture competition can be seen as a great act of public imagination. For a major civic project, it provides an opportunity not only to add a new physical space but also to help shape a city for many generations to come. As the Art Gallery director, I had the honour of chairing the Sydney Modern Project competition jury including six other members internationally renowned for their expertise: Kathryn Gustafson, Michael Lynch, Toshiko Mori, Glenn Murcutt, Juhani Pallasmaa and Hetti Perkins.[6] Then board president Guido Belgiorno-Nettis and deputy director Anne Flanagan provided active support throughout the process, which started with the selection of around fifty Australian and international architectural practices by an architects advisory panel for the jury's consideration (see p 214).[7] From this list the jury selected twelve practices to invite to participate in Stage 1 of the competition.[8] Their submissions were judged anonymously in January 2015, with five practices then shortlisted to participate in Stage 2: Kengo Kuma (Tokyo), Kerry Hill

The Sydney Modern Project competition jury in January 2015. From left: Hetti Perkins, Glenn Murcutt, Kathryn Gustafson, Michael Brand, Michael Lynch, Juhani Pallasmaa, Toshiko Mori

A future to dream into

(Singapore and Perth), Rahul Mehrotra (Boston and Mumbai), SANAA (Tokyo) and Sean Godsell (Melbourne). Their evolved submissions were assessed in April 2015 after a site visit and presentations to the jury. SANAA, led by founders Kazuyo Sejima and Ryue Nishizawa, was announced as the winner of the competition in May 2015.[9] Its team would work with executive architects Architectus and landscape architects McGregor Coxall, both based in Sydney. In its design statement, SANAA summarised its concept of the building:

> The new building is composed of a series of pavilions of various sizes and gallery volumes, which sit lightly across [the site]. The low roofs step and shift gently along this topography to preserve existing significant trees, sight lines, and the contour of the site . . . [By] integrating art, the topography of the site, and the surrounding landscape, we hope to create an art museum experience that is distinctive to Sydney.[10]

The jury's comments on SANAA's winning Stage 2 submission show how the architects had kept in balance our dual goals of expansion and transformation:

> Its lightness of form speaks to the new century while respecting the architecture of the previous centuries to create a harmonious and inspiring new public space for Sydney. The scheme is futurist in its thinking about art museums and the visitor experience and will be transformative for the Art Gallery. The scheme elegantly places Aboriginal and Torres Strait Islander art at its heart.

> This is a twenty-first century concept that has the full potential when developed to be an environmentally sensitive art museum. The scheme starts to deconstruct the classical art museum and offers opportunity for further development of new types of spaces for the display of a variety of art forms, both existing and new.[11]

* * *

SANAA and the Art Gallery team would need to work together to bring this competition concept embedding our dreams for the future to a construction-ready design. In this final creative phase of a project, the relationship between the art museum director and the architects becomes critical. Trust, as Anthony Burke identifies in his essay (see p 81), would be crucial to all aspects of the project's success. As director of the Art Gallery, I would need to ensure that a fully respectful relationship was established, as well as a creative partnership that would offer the greatest chance of an exceptional architectural outcome. I not only had to bring the architects and their design ambitions into dialogue with the Art Gallery's professional staff but also its external stakeholders, which in our case included our board of trustees and various government entities. Together we needed to harmonise SANAA's central architectural concept with the institution's broader vision of how our visitors would engage with art across our expanded campus. And while the evolution of the architectural concept would suggest new curatorial opportunities, it was equally essential that the Art Gallery's curatorial strategy would, at the same time, suggest new design directions.

For the Sydney Modern Project, this phase was driven by a series of over twenty design workshops in both Tokyo and Sydney, which started immediately after the competition was concluded in 2015.[12] As foreshadowed in the competition brief, the Art Gallery engaged SANAA at the conclusion of the competition for an initial engagement phase of twelve months, enabling design work to commence while fundraising and planning approval processes began. A notable feature of the workshops held in SANAA's Tokyo studio throughout 2015 and 2016 was the extensive use of 1:500 scale cardboard models.[13] These functional models were manipulated freely during our meetings, allowing possible changes to be assessed in three dimensions in real time: roofs were ripped off, twisted and reshaped, spaces were realigned and pushed sideways. This simple, if somewhat destructive, process led to a number of significant design changes – as well as large stacks of miniature 'Sydney Moderns' in the SANAA studio. As we continued to work

Above, from top: SANAA's model of Naala Badu; Work-in-progress models in SANAA's Tokyo studio, 2015

Michael Brand

together, the strength of SANAA's concept became even clearer: while many aspects of its competition submission were revised, the multi-pavilion concept moved forward happily intact as architectural imagination was guided towards concrete form.

The biggest change to SANAA's design took place in 2016 after David Gonski returned for a second term as president of the Art Gallery's board of trustees, tasked with the responsibility of ensuring both public and private funding for the project.[14] After a fresh investigation of all potential funding sources, we decided to pull back almost all built form from the top of the land bridge. Significantly, this meant removing a proposed link between the two buildings, but two benefits soon emerged. Firstly, the contraction of the layout of the pavilions allowed for the insertion of a single vertical circulation spine. And, secondly, the clearing of built form from the land bridge created a 'third element' between the two buildings that was soon conceived of as an 'art garden' which would bring landscape into the heart of what could then become an art museum campus. The key funding success came in June 2017 with the announcement of A$244 million from the state government, contingent on the Art Gallery raising another $100 million through private philanthropy.[15] This private target was surpassed in June 2018, thanks especially to a lead donation from Isaac and Susan Wakil, making it Australia's largest government and philanthropic funding partnership in the arts at the time.

The SANAA team was finally able to visit one of the oil tanks in September 2017. The architects entered the southern tank via a manhole and descended by a scaffolding staircase, wearing rubber gumboots since water still covered some parts of the floor. Almost immediately, they termed the tank 'Sydney's treasure' and abandoned plans to add a mezzanine across part of the space. The southern tank, measuring 2200 square metres with 125 columns on a 4-metre grid, would now be preserved as close as possible to its original form.[16] Only a white steel spiral staircase in one corner would eventually reveal SANAA's hand.

With the submission of the State Significant Development Application in November 2017, the final form of the new building was complete. Set adjacent

SANAA viewing the empty oil tank in its original state prior to construction, 2017. From left: Ryue Nishizawa, Asano Yagi, Kazuyo Sejima

A future to dream into

to the Art Gallery's original building, it would feature a decentralised cluster of pavilions descending through parkland towards the harbour. Creative teamwork at multiple levels had brought further finesse and practicality to the competition design, with interstitial spaces offering the potential for new types of art experience and art commissions that would provide new types of engagement with the architecture and landscape. As Eve Blau notes in the following essay (see p 73), SANAA acknowledges the Sydney building as a site of continuing experimentation and discovery. The final design embodied what Sejima described as a continuing focus from the very beginning of her practice:

> My vision was to connect those internal and external spaces; to create an internal space that would link any actions that take place inside; and make an external space that is in continuum with the environment that extends further outside. In other words, I wanted to create a place in which our actions and environment would link together. And I had a feeling it would be a space like a park.[17]

In the same publication from 2018, Nishizawa wrote about how 'architecture creates space that is larger than the building itself'.[18] And in the case of their design for the Art Gallery, it could be added, larger than it appears from the outside. Lacking a singular facade, it reveals itself slowly to the visitor.

The first element of SANAA's new building to be encountered is the Welcome Plaza, shaded by a 7-metre-high, wave-form glass canopy embedded with white ceramic fritting resembling a cloud caught between the layers of lamination (see p 38). The glass-walled Entrance Pavilion, whose roof covered by 735 photovoltaic cells helped us achieve the highest sustainable design rating, then leads to the three main art pavilions that descend towards Woolloomooloo Bay, clad in over 50,000 white limestone bricks. At each level of the building, we have named galleries, spaces and architectural features in recognition of leadership and founding donors who were instrumental in bringing this vision to life, ensuring their legacy is embedded in the building's fabric. Their names are listed on pages 216–17, along with other key supporters of the Sydney Modern Project.

One of my favourite views is looking down from a glass balustrade in the Entrance Pavilion, where the building's surprising scale fully reveals itself as the three art pavilions approach each other under a wing-like roof to form an atrium rising 13 metres from lower level 2. This atrium is backed by a curved wall sweeping 150 metres through the building, starting outside at one end before concluding outside again at the other. A gallery for time-based art is set behind the northern end of the wall, while a multipurpose hall extends into a garden. Casting a glow in the Entrance Pavilion is the translucent Gallery Shop designed by Akin Atelier, with its curved walls constructed from bio-resin developed in collaboration with local surfboard designer Hayden Cox. Visitors can move all the way from Art Gallery Road to the lifts and escalators in the Entrance Pavilion without encountering a single step. Inside the building, three glass-enclosed lifts connect all levels down to the loading dock and the Tank below.

How to bring visitors from the entrance down two levels to the Atrium was challenging physically and conceptually. Eventually, two sets of escalators were inserted, mimicking the descent through the Art Gallery's original building. Starting from the viewing terrace beyond the Entrance Pavilion to the north, an alternative outdoor pathway takes visitors down across a stepped terrace on top of the Atrium to the dining terrace of the restaurant that sits on top of the lowest art pavilion. The Tank can also be accessed from the Atrium via SANAA's triple-corkscrew spiral staircase.

* * *

With the design of the building finalised, it was time to refocus on art and add more voices to the Art Gallery team as the next stage of curatorial and programming issues were workshopped in more detail.[19] Now we could focus on ensuring that the visitor experience was as 'distinct to Sydney' as SANAA had promised, and as 'futurist' as the competition jury had hoped. The overarching goal was to create an art experience deeply grounded in a sense

Michael Brand

of place on Gadigal Country in Sydney, with a strong Indigenous voice right across the campus. It was decided not to impose strict chronological division between our two buildings. While displays in the original building would continue to include contemporary art within its loose historical and geographical narrative, the new building would also nurture dialogues with the past.[20]

The three art pavilions with their ceiling heights of 5.5 metres form the central focus of the art experience in the new SANAA-designed building. The most important curatorial decision was to relocate Yiribana, our gallery for Aboriginal and Torres Strait Islander art, from the lowest level of the original building to the 1000-square-metre art pavilion on the entrance level of the new building. The column-free 1100-square-metre art pavilion on lower level 1, with its wall of glass looking towards Woolloomooloo and the Garden Island Naval Precinct, was dedicated to our collection of contemporary art, while the 1300-square-metre pavilion on lower level 2 was allocated to major exhibitions. With SANAA's design blurring the traditional boundaries and hierarchies between white-cube galleries and circulation zones, significant art experiences were also developed for the building's interstitial spaces. Here, in a significant conceptual leap, the art is lit mainly by ambient light, linking it more closely with the external environment. The visitor's experience is augmented by two dedicated physical spaces for learning and participation, and digital programs that take advantage of 5G connectivity throughout the building.

The final step in weaving art together with architecture and landscape was the commissioning of nine site-specific artworks across the campus. Six artists were commissioned for the new building: Francis Upritchard in the Welcome Plaza, Lorraine Connelly-Northey in the glazed Yiribana Gallery loggia facing the Art Garden, Yayoi Kusama on the stepped terrace looking out over the harbour, Lisa Reihana on a 20-metre-wide screen above the Atrium, Richard Lewer on the rammed earth wall leading to the Learning Studio, and Lee Mingwei located at the end of an external garden pathway leading northwards from the Atrium. In the Art Garden between the original and new buildings is a major commission by Wiradyuri and Kamilaroi

artist Jonathan Jones, creating symbolic Country while highlighting Indigenous knowledge, especially that relating to landscape management. The two remaining commissions, by Simryn Gill and Karla Dickens, were destined for the original building, the former in a series of immense prints in a temporary exhibition and the latter in a niche above the front entrance.

A groundbreaking ceremony, including a moving multigeneration Indigenous Welcome to Country, was held in November 2019 before Richard Crookes Constructions embarked on a construction program lasting close to three years, which was managed on the Art Gallery's side by our head of project, Sally Webster (see p 135), and for Infrastructure NSW, Andrej Stevanovic. Sejima and Nishizawa attended the event with their SANAA colleagues but, due to travel restrictions imposed after the outbreak of the COVID-19 pandemic in early 2020, the SANAA co-founders would not be able to visit Sydney again until construction was almost complete in mid 2022.[21] Asano Yagi stayed on in Sydney as SANAA's senior designer and project manager, enduring three periods of quarantine. Except during the two Sydney lockdowns in 2020 and 2021, monthly meetings of our external Project Control Group and weekly meetings of our internal Project Working Group took place in our boardroom in the original building overlooking an increasingly active building site to the north.[22] The final design decisions of consequence related to material finishes, in particular the selection of rammed earth for the 150-metre-long wall that sweeps through lower level 2, and another 100 metres of wall on lower level 1, constructed between 2021 and 2022 by John Oliver's Rammed Earth Constructions from Maleny in Queensland. Many prototypes were tested before a result was achieved that evoked the organic nature of Sydney sandstone and the rocky escarpment into which the building is set, the same warmth echoed in the tone of concrete floors designated for all but two of the gallery spaces (see p 190).

True to our original focus on landscape, the designing of this component of the Sydney Modern Project continued throughout this phase under the

The reflecting pools designed by Kathryn Gustafson on the forecourt of Naala Nura, looking towards Naala Badu

A future to dream into

Michael Brand

leadership of Sydney's McGregor Coxall and then also landscape architect Kathryn Gustafson and her Seattle-based firm, GGN. Gustafson had produced a masterplan for the Art Garden between the two buildings, first discussed with SANAA and artist Jonathan Jones at a workshop in Tokyo back in December 2017, as well as the design to reconfigure the forecourt in front of the original building by removing car parking and adding two black granite reflecting pools. More than fifty thousand plants, including 370 trees, almost all of them native to Australia, would be planted across the expanded campus as part of the overall landscape scheme, including on roof terraces and non-accessible green roofs.

Construction of the Jonathan Jones commission *bíal gwiyúŋo (the fire is not yet lighted)* commenced in 2022, and logistical planning continued for the annual cultural burning that will be staged once the plants are well established. Following Indigenous landscape management practices, the kangaroo grass (*Themada triandra*) – growing beneath *Xanthorrhoea* 'grass trees' and the highly sculptural *Banksia serrata* trees – will be subjected to a cool burning each year that triggers the start of seeding and regeneration of these native Australian plants. Through this action, and an annual cultural program that is an integral part of the work of art, a powerful Indigenous voice will resonate from the heart of the Art Gallery's expanded campus.

As part of the new building, Lee Mingwei's *Spirit House* commission perfectly embodies the relationship of art, architecture and landscape central to SANAA's design. The result of a collaboration between the artist and SANAA, this small, womb-like, rammed-earth cavern is reached via a curved garden path flanked by swaying native grasses and entered by a door cut through the northern end of the sweeping wall. Inside, visitors have a solitary encounter with an image of the Buddha cast in bronze by Taiwanese master sculptor Huang Hsin Chung. The sculpture was placed for a week at the Nan Tien Buddhist temple near Wollongong, south of Sydney, before it was installed at the Art Gallery and consecrated in a ceremony in which staff participated alongside the artist. Once each day a small rattan-wrapped stone is

set in the Buddha's hands and can be taken away on a journey by the fortunate viewer who first encounters it. Lee has said,

> I would like the visitor to look into their own life experience, and how the work can initiate a conversation when they look inward. It may be nothing at all, or it may be something profound. I hope the work will create a sense of resonance with their personal story, and once that is formed, there are infinite possibilities.[23]

* * *

A week of preview events preceded the 3 December 2022 public opening of our new building, first popularly known as 'Sydney Modern' and now named Naala Badu. The first through the door were 1500 students from fifty-two schools across New South Wales, from neighbouring Woolloomooloo right out to Wilcannia, almost 950 kilometres north-west of Sydney. They were welcomed with an Indigenous smoking ceremony, entering SANAA's architecture through a screen of eucalyptus smoke pierced by the sound of clapsticks.

The Sydney Modern Project was now complete, on schedule and within budget. From the depths of the awe-inspiring Tank, SANAA's limestone and glass Naala Badu building bloomed in the Sydney landscape, its white spiral staircase rising like the stem of an auspicious lotus flower from a muddy pond. To the inwardly focused historical foundation of the Art Gallery's original building with its modernist additions (now named Naala Nura) had been added an inspiring range of indoor and outdoor art and education spaces true to their urban parkland setting.

The stage was now set, and the Art Gallery was ready to welcome visitors to Naala Badu and create new pathways through art across our entire campus. The public response has been phenomenal. Inspired by new art experiences worthy of cosmopolitan Sydney, visitation to our expanded art museum exceeded two million in its first year of operation, placing the Art Gallery among the world's top thirty most-visited art museums.[24]

Yuin elder Les McLeod leading a smoking ceremony welcoming students to a schools preview day, November 2022

A future to dream into

One of our main goals was to make even more ambitious exhibitions possible in Sydney, and *Louise Bourgeois: Has the Day Invaded the Night or Has the Night Invaded the Day?* is exactly the sort of show we envisioned. This first major ticketed exhibition in Naala Badu, which opened in November 2023 as part of the Sydney International Art Series, showcased Bourgeois's formidable oeuvre over two levels, including a unique installation in the darkened Tank.

Expanding our programming to include more boundary-crossing live music, film and performance was another goal of the Sydney Modern Project. The Art Gallery's innovative *Volume* series, headlined in its inaugural year of 2023 by Solange's commission in the Tank, has offered visitors an opportunity to experience the varied spaces of a twenty-first-century art museum like never before. [25]

Since opening, Naala Badu has been recognised with numerous awards, including the 2023 Sir John Sulman Medal for Public Architecture and *Apollo* magazine's international museum opening of the year.[26] Among the many positive reviews we have received, the Pulitzer Prize–winning art critic Sebastian Smee wrote in the *Washington Post*:

> American museum professionals engaged in rethinking their own museums should try to figure out what they can learn from Sydney Modern. Some of the specific lessons won't be applicable. But that's just the point: There is no replicable formula. Instead, there is a deep, underlying lesson: Be as dynamically and thoughtfully in tune with the city and culture around you as possible. Do the work yourself. Don't copy others. [27]

Sydney now has its own, unique art museum where citizens and visitors alike can engage with historical and contemporary art practices from around the world. Through their design for Naala Badu, SANAA has helped us reshape the Art Gallery of New South Wales, giving concrete form to a future that is no longer a dream.

Installation view of the exhibition *Louise Bourgeois: Has the Day Invaded the Night or the Night Invaded the Day?* in the Nelson Packer Tank

Michael Brand

Lee Mingwei *Spirit House* 2022

Photo essay I

Iwan Baan

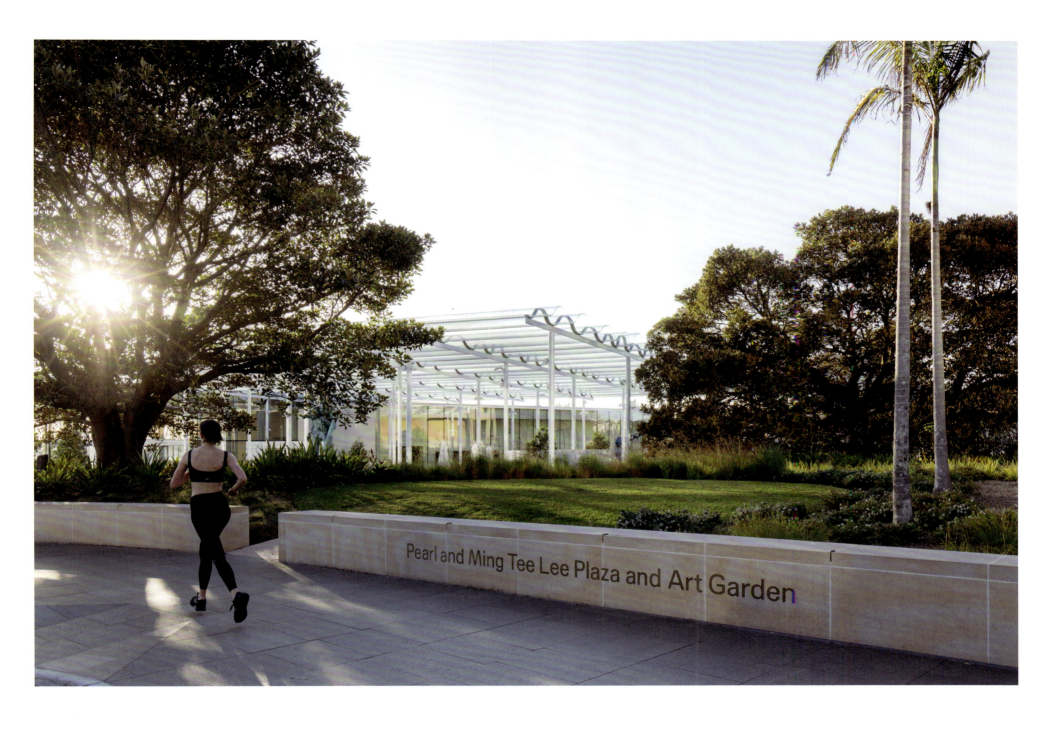

Pearl and Ming Tee Lee Plaza and Art Garden

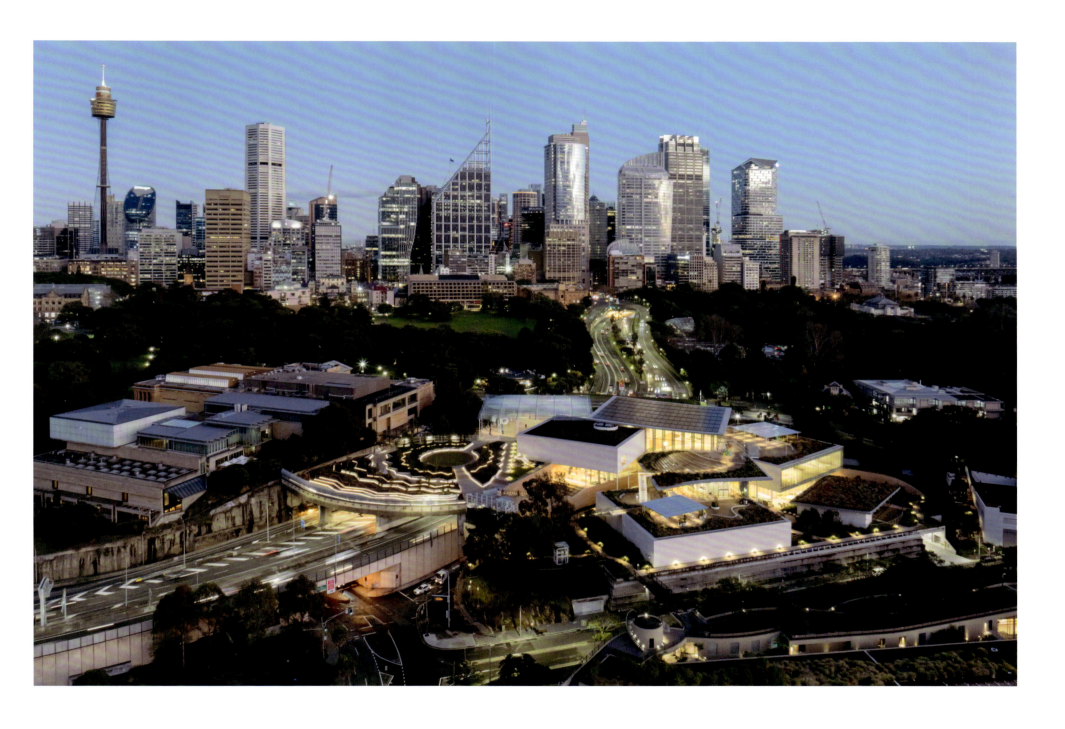

Staging the unpredictable

Eve Blau

Staging the unpredictable

The museum is a site for experimentation in SANAA's practice. Each museum is a testing ground and exploration of new directions in the firm's work. Experimentation is about discovery and designing experiments that push the boundaries of knowledge. But in architecture, just as in science, it is not enough to design the experiments; one has to study and act on the results if the experiments are to produce new knowledge. As an architectural problem, the museum is tasked not only with shaping spaces for the display of art objects, but with shaping a certain kind of encounter – a coming together, a meeting, a collective experience – that is specific in place and time. The nature of the encounter depends on what each visitor brings to and takes away from that experience. Experience is of course infinitely variable. But it can be shared. The task for architecture, as SANAA sees it, is to create the conditions that make the encounter possible.

'What happens inside the museum,' Kazuyo Sejima has said, 'cannot be easily predicted. In fact, we have to make something that realizes the unpredictable ... every encounter will bring forth another new image of this museum.' This is the experiment that she and Ryue Nishizawa are conducting in their new building for the Art Gallery of New South Wales. It is an experiment that began with SANAA's first museum, the 21st Century Museum of Contemporary Art in Kanazawa (2004), was carried forward and taken in new directions in Sejima's Art House Project on the island of Inujima in Japan's Seto Inland Sea (2010–), and which moves into exciting new territory with the Art Gallery's new building, Naala Badu, created as part of the institution's transformative Sydney Modern Project. Let's start at the beginning.

In Kanazawa the experiment is conducted in controlled 'laboratory' conditions. The building is perfectly cylindrical. It has glass walls and many points of entry. The outer walls are alternately transparent or reflective, depending on the time of day, angle of the sun, and weather. At times they allow one to see deep into the centre of the building. At other times they become reflective, bouncing back images of trees, houses, and people moving among them. Because of the many layers of glass, the walls not only reflect the spaces they enclose

but they also visually project those spaces onto, through and beyond one another. Inside, each space – whether exhibition gallery, library, restaurant or lecture hall – is both shaped into an independent volume and intricately interwoven with those around it. This is an organisation that combines coherence and legibility with an openness that allows for the unpredictable to occur.

The instrument for staging the unpredictable is an organisational strategy based on two orders of transparency. The first is 'functional transparency', a clear organisation of spaces and ways of circulating through them that clarifies patterns of movement through the building. The second is what Sejima and Nishizawa call 'visual transparency', which cuts across the spatial organisation of the plan and introduces a contradictory optical pattern of connections and disconnections that adds layer upon layer of visual information. It is a configuration in which the information inscribed in the physical organisation of the spaces – the plan – often seems to contradict the visual experience of those spaces.

But the multilayered transparencies also reveal the social agenda of the museum: they show the potential of each space to be open and closed, to be connected and separate from the others, to offer solitude and society, glimpses of nature and self-reflection, places of rest and activity. They allow 'People [to] see each other, communicate, and also understand their position in relation to other people.'[2] It is a spatial organisation that is both carefully orchestrated and radically open to variation and interpretation. It allows visitors to orient themselves while heightening their awareness of the art and their own relationships to things and spaces around them. 'It's the gathering of all those experiences,' Sejima explains, 'that actually makes up the building.'

For SANAA, the double spatial logic of independence and interconnection produces what Sejima calls 'public space'. This is a space defined by human activity. It allows one to be alone and in company at the same time; it is a condition predicated on freedom and flexibility of use, which provides both autonomy and connection. Sejima and Nishizawa frequently use the metaphor of the park to describe the options that such spaces afford: 'In a park,'

Lower level 1 of Naala Badu, looking up towards the Yiribana Gallery, featuring artworks by Rusty Peters (above), Richard Lewer and Takashi Murakami

Eve Blau

Sejima writes, 'you can join a big group, but at the same time, somebody could be next to you alone, reading a book or just drinking juice.'[3] Nishizawa elaborates, 'one creates an adventure, an experience ... an itinerary.' But, he insists,

> It's not so much the author of the spaces that creates the itinerary: each visitor creates his or her own, different and specific itinerary. It is very much a democratic approach to the museum. It's both a museum and a park. It can also be an urban space. That's what we have in mind when we design a museum.[4]

Is it possible to identify an experimentalist architectural practice in these ideas about the co-production of the space of the museum with its users?

Experimentalism in art was first identified by the musician John Cage in the late 1950s to distinguish his own practice in the field of music composition from that of the avant-garde. Cage's distinction was based on his definition of experiment as an act with an unknown outcome – a science-based definition.[5] In science, experimentation is an operation carried out under controlled conditions in order to discover something unknown, to test a hypothesis or law. It involves a set of protocols adopted in uncertainty. Cage conceived his own practice in these terms: as open-ended, interactive and contingent on the circumstances of performance (listening, he claimed, was an important part of the production of music). He aspired to what he saw as the openness to experience the architectural work and the interactive construction of meaning with viewers and users of the work.

Architectural historian Manfredo Tafuri also recognised what he saw as 'the existence of a deep contradiction between the avant-garde and experimentalism'. In architecture, he claimed, 'experimentalism is ... constantly taking apart, putting together, contradicting, and provoking ... Its real task is not subversion, but widening.' In architecture, just as in science, it is not enough to launch the experiments, one has to study the results – 'to check the effects on the public', is the way Tafuri put it – and act on them

if the experiments are to generate new knowledge. Experimentalism defined in this way is predicated on the actuality of the built work in physical space, which gives the architecture – beyond the intentions of its author – the agency to impact and act on the social and physical world.[6]

In SANAA's studio the method of work is almost purely experimental; concepts are developed, options are tested, studied and redesigned in countless physical and digital models that are examined under 'laboratory conditions'. According to Nishizawa, 'if different options are not developed, the project doesn't exist ... every option must have a plan, drawing, and a model.'[7] The studio is piled high with study models, hundreds of which are generated for each project. 'We try to find many reasons for any decision,' Sejima explains, 'and then finally we can decide. But still, I think there are always other options.'[8] The scheme that gets built is not the ultimate 'solution', but rather one among many equally viable options.

The iterative nature of this method of testing multiple options in linear progression before developing any one design, is often seen as aligning SANAA's work with art practices. But they are probably more accurately understood in terms of Tafuri's conception of experimentation as 'checking the effects on the public'.[9] Yuko Hasegawa has said of Sejima and Nishizawa that they

> simply want to place the architecture and observe what will happen, rather than predicting and planning what effect it will have on the surrounding environment. They cannot possibly grasp the 'whole' by completing the physical building. The architectural design reveals itself in time and is given its 'wholeness' through the relationship with the people who use the building and the surrounding environment.[10]

In architecture as in science, the experiment does not end with the construction of the work but continues long after the work has entered the world of lived experience. Sejima notes that sometimes, 'the completed architecture, even though it is finished ... has something of the model about

Exterior view of the 21st Century Museum of Contemporary Art in Kanazawa

Staging the unpredictable

it [and] I get the feeling that something new is about to happen'.[11] So, the process keeps the experiment open.

The sense of latency in SANAA's architecture is one of the most compelling and significant qualities of its work. One that animates the Art Gallery's new building. It marks a turn in SANAA's design thinking from a concern with the individual architectural object to considering architecture as part of a larger ecosystem; a shift in thinking from the binary terms of object–subject relations to the diffuse terms of environment and ecology. It reaches its fullest architectural capacity in Sydney. But, as both Sejima and Nishizawa insist, it began with Sejima's Art House Project on the island of Inujima in Japan's Seto Inland Sea.[12] Let's go there.

The Art House Project is an architectural experiment that attempts to integrate the spaces of daily life with those of the museum without destroying the natural, social and cultural ecologies of Inujima Village. It is an ongoing experiment which began in 2010 and is carried out in 'real time' and in 'lived space'. It consists of a series of small structures scattered throughout the village of Inujima. The island itself is tiny (even at a leisurely pace, Sejima notes, it takes only 20 to 30 minutes to walk around it) and deeply scarred. Stone quarrying has hacked away great chunks of the island. In 1909 a major copper refinery was built on the island, but within ten years operations stopped and the factory closed down, a casualty of

plummeting copper prices after the First World War. Inujima Village, which is situated on gently sloping hills around a small inlet and harbour, is even smaller. It has around fifty inhabitants. The median age of the villagers is seventy-five years, and the population is shrinking.

'I came up with a plan,' Sejima explains, 'to turn the hamlet into a "museum" by renovating or rebuilding about ten of the houses there … that museum will also create a new environment.'[13] Integrating old and new building fabric, art and dwelling space, Sejima's interventions fit comfortably among the houses and gardens of the village, echoing the rhythms and patterns of daily life around which they have been shaped. They are remarkable for the recessive quality of the architecture, which deflects attention from itself to the spaces and objects around it.

This is museum design as caretaking, display and interpretation. It is also a controlled experiment to 'turn a village into a museum' without destroying its fragile natural, social and cultural ecologies. For Sejima, the Art House project was a watershed in terms of thinking about creating architecture at one with the environment.[14]

At first I had no idea what to do. I had never done a so-called renovation project … At the opening I explained my thoughts behind the design of each [gallery]. But it felt meaningless somehow – 'I did this, I did that … '. I realized I hadn't been

Inujima Art House Project, A-Art House, featuring Haruka Kojin's installation *reflectwo* 2013

Eve Blau

able to convey the appeal and potential of Inujima ... But once I began thinking of the entire island as a single work of architecture ... I realized that I could apply the same approach I used for architectural design to the village, or even the whole island. I found that it freed me to ... think of creating architecture as one and the same as creating an environment.[15]

In the Sydney Modern Project these ideas came together in a new art museum building that takes them in a radically new direction. Here the experiment is no longer tightly controlled but moves decisively outside the laboratory, relinquishing control to explore new strategies for staging the unpredictable. As its name suggests, the Sydney Modern Project was for and about Sydney; a modern project firmly lodged in the present, part of a continuum (not severed from the past), and purposefully directed toward the future. The new building is charged not only

with expanding the spaces, collections and programs of the Art Gallery of New South Wales, but with giving form to an institution that has fundamentally reinvented itself. The task is as multifaceted as it is consequential. It involves spatialising far-reaching curatorial and museological agendas to transform traditional curatorial practices, by recentring the Art Gallery's collections around Aboriginal and Torres Strait Islander art; bringing Indigenous and non-Indigenous art into dialogue; constructing new, more complex and inclusive narratives; and bringing the institution as a whole into closer dialogue with its site, the city, and its history.[16] The building's charge, in other words, is to give form to the ongoing dynamics of change. The process is program driven. It begins with the first encounter.

Side by side, the old and new buildings establish the terms of engagement. The monumental classical forms and symmetries of the original Art Gallery facade speak of power, privilege and colonial exclusions. SANAA's

Stairway between the terraces of Naala Badu, with a view through to the restaurant

Staging the unpredictable

canopied Welcome Plaza, with its thin white columns and transparencies, is accessible, open and accommodating. Inhabited by fantastic sculptural creatures, Francis Upritchard's friendly, anti-heroic giants, it speaks of inclusion and the promise of adventure. From here, visitors move easily into the low, transparent Entrance Pavilion and then, nudged forward by the gentle incline of the floor, into the building's central space, which, in a dramatic explosion of light, structural beams, escalators and floating stairs, opens out into a multilevel atrium, a space of access and orientation that allows one to see all of the museum's stepped floor-levels, the connections between them, and the multiple options for circulating through them. It also opens onto panoramic views across the site and Woolloomooloo Bay and gives access to the museum's imbricated terraces that step down the sloping site.

The Atrium itself has the quality of an urban public space – open, accessible and constantly transformed by the activities within it. Dispersed within that space, the various programming functions of the museum are formed into independent volumes that have their own distinctive proportions and material properties. The glazed circulation and other interstitial spaces are clearly figured and easily legible. Other museum functions are assembled into interlocking pavilions that fan out across the site and cascade down its steep incline, while opening their spaces to view from Woolloomooloo. They are all closely interwoven. Throughout the building, curatorial and architectural narratives connect and act on one another, weaving in and out, as they thread their way through the enclosed galleries and the transparent spaces that link them. Together they create an internal landscape with its own dramatic topography of outcroppings and layerings that evokes the sharply graded topography of the site, merging inside and outside.

Unlike SANAA's earlier museums, in which form is primary and program effectively disappears into the building, here program pushes back, disaggregating the whole into an assembly of parts – volumes and planes that slip in and out of alignment as they tumble down the steep escarpment – making it difficult to understand the building in terms of form. It is only through use, by engaging deeply with the works of art and charting one's own course through the galleries and spaces that connect them, that the building begins to cohere and become legible. In this way the building provides a generous and flexible infrastructure that not only supports multiple narratives and itineraries, but also gives voice to the museum's users, sharing authorship of the architecture with them.

The building also operates at environmental scale, incorporating existing structures on the site along with their histories and accumulated meanings – absorbing a decommissioned Second World War naval fuel tank into the exhibition space of the museum and incorporating the land bridge into the museum garden. Digging deep and fanning out, it also extends far beyond the site, drawing in the industrial infrastructure and fabric of Woolloomooloo, the Finger Wharf and Garden Island Naval Precinct (the only locations from which the whole building is visible) bringing them into conversation with one another and with the Botanic Garden, the Domain and city centre. As such, Naala Badu carries forward the experiment that Sejima began in Inujima, 'to think of creating architecture as one and the same as creating an environment'.[17]

It also greatly expands that experiment in ways that are as exciting as they are consequential, and which take the project itself into new and uncharted territory in SANAA's work. Here, the questions driving the enquiry are: Is it possible, as Sejima and Nishizawa propose, to 'create architecture that also creates the environment over time'? How can the museum participate in that effort? The initial findings of the experiment suggest that museum architecture, by operating at the scale and with the social purpose of infrastructure – by bringing together and integrating disparate elements in the environment while allowing them to retain their identity, and thereby embedding the museum in the culture and topography of its site – has the capacity to catalyse change and to create the conditions for innovation. The results, of course, are still being studied. The experiment continues.

Eve Blau

Trusting architecture by looking between: on context and relationality in SANAA's new building

Anthony Burke

There have not always been museums, and when they
did exist, they were not always of the same type. They
changed with the cultures to which they belonged.
The life story of the art museum is the story of growing
ambitions and responsibilities.[1]

Alexander Dorner

Renowned US émigré museum director Alexander Dorner argued that art museums in the early postwar period needed to cast off the ideas of chronology and curation from a dead past, and 'become integrated with the present'.[2] His thesis, developed in the midst of the Second World War, sought to position art museums not as collectors of the past, validators of beauty and class, but as 'active factors in the moulding of the future'.[3]

Anthropologist Margaret Mead, only two years later, in assessing the anthropological dimensions of the future museum, noted, 'One of the problems of our emerging culture is to learn ways, which have never even been approximated yet, of blending the essence of permanent human preoccupations with the accidents of idiosyncratic, local, time-limited experience.'[4]

From the vantage of the mid century, Dorner and Mead captured the project of the twentieth-century 'modern' art museum, to reverse the view of museums from the past to the future, from passive collection to active engagement. Mead, in particular, hinted also at the subsequent art museum project of the twenty-first century, recognising the possibility of the gallery as a space of production and action within an unsettled network of social, cultural and spatial co-dependencies. The 'idiosyncratic, time-limited experience' was a space of possibility, held up as an alternative to the rarefied air of a sanctioned institutional collection.

And it is in this space of relationships and co-dependencies that SANAA's new building for the Art Gallery of New South Wales takes up the question of the twenty-first-century art museum as a project, challenging many of the shibboleths of (Australian) architectural expectations, and the excesses of the image-ready edifices that dot the Arabian Peninsula and beyond. By rejecting both the 'icon' and an 'uncritical regionalism', the Art Gallery's new building, Naala Badu, offers a place for a post-covid humanism, an earnestness where people 'meet in architecture',[5] while offering a serious, nostalgia-free re-examination and update of the potential of the local Australian (now urban) landscape. All this, while asking the only question that matters, 'what does an art museum do?'

SANAA's answer starts with the unconventional architectural idea of trust.

* * *

Ryue Nishizawa, co-principal of SANAA, has written, 'I think we trust people a great deal; we want them to use our architecture in ways that we don't anticipate.'[6]

It takes a moment for the import of this humble statement to really land, but its implications for architecture are hugely significant. Cloaked in a humble humanism, an architecture built on trust and the notion of fostering, rather than resisting, the co-dependency of a building with its cultural and material context, is nothing less than a reassessment of the Western philosophical grounding of architecture in the idea that the institution, the state, the patron and the church are holders of wisdom not just expressed but sanctioned and delivered in stone.

SANAA takes a very different position. Its approach to architecture is to step away from the excesses of form and attention and redirect that energy towards the context, the visitors, the art, something they have been exploring in various ways since their early works in the mid 1990s. For SANAA, the role of architecture is not to 'express' the three poles of people, place and art, as much as to stage or activate them, trusting the success and expression of the architecture to the dynamism of their changing relationships as they play out every day.

Trusting, in this sense, also requires acknowledging a co-dependence, an idea distant from the galleries of the modern century, which claimed autonomy and moral authority as central tenets of their conception. The power and novelty of the modernist building is precisely its distinction from the tawdry world from which it offers escape. In discussing relationality as opposed to the autonomy of late modernism, Brit Andresen writes, 'architecture may play a role in structuring relationships rather than in diminishing them, an architecture of interaction between people and their environments, as opposed to an architecture of separation'.[7]

To foster this fundamental connectedness, trust demands an architecture that acknowledges its co-dependence on factors beyond the building itself,

Visitors in the Pearl and Ming Tee Lee Plaza, with Francis Upritchard's *Here Comes Everybody* 2022

Anthony Burke

both human and otherwise, relying on them to complete the project. The Art Gallery's new building works this way, finding its raison d'être in its very entanglement of relationships with the world and its intricacies. In this sense, SANAA's is an architecture of humility, one that understands and modestly takes up its role as a part of a whole rather than a whole unto itself.

This is something that Nishizawa has spoken about as the difference between Western object-oriented additive architecture and experiential Asian architecture 'integrated with nature', while pointing to the centrality of the concept of structure. In English, the term 'structure' seems at first to be straightforward, alluding to the *techne* of Western architectural tradition, the beams and columns or material ordering of space set out through the grids and frames of a building. Nishizawa's use of the term 'structure', however, is more nuanced and verbal, as in 'to structure' or to create a relationship.

Kazuyo Sejima, co-principal of SANAA, is equally committed to the idea of building as a spatial 'nesting' of relationships but couches the concept in the idea of spatial flow and continuity and a consequent borderlessness of space that generates intensities of atmosphere and program to 'shape' a plan. When working on the Inujima Art House Project (2008–10) for example, she described the small village as a continuous architectonic space. In creating an uneven seamlessness of experience over an extended landscape, she recognised only the intensity of spatial conditions or atmospheres, rather than the typical urban artefacts of street, house and temple.

> Kazuyo Sejima: The conditions of light in a space constantly change in a way that resembles the variations of light and shade in a painting.
>
> Ryue Nishizawa: To us, those phenomena are part of the structure ... they only exist as a result of the structure ... We are always thinking about the relations among elements, i.e., their structure, and that is what determines the appearance of the building.[8]

Japanese architect Arata Isozaki wrote about this 'natural distance between two or more things existing in a continuity ... giving rise to both spatial and temporal formulations' as 'Ma, space-time'.[9] Bringing this concept to the West in 1978, his work was an attempt to articulate a particularly Japanese understanding of place and void over form and object, one that is intensely relational and based in experience or time. Hence, one looks not to the masses as forming the architecture, so much as the spaces between them, *in time*.[10] As accidental and informal as the variously called 'between' or 'Ma' spaces might appear in SANAA's projects, they are the carefully studied 'structurings' that are the essence of their work, which produce a gentle architecture that whispers to you, rather than shouts.

The three gallery volumes of the Art Gallery's new building therefore play a distinct but subservient role as they *structure* the intricate void spaces between them throughout the building, while anchoring the collection *that has happened*, as Dorner might say. But the art to come expects no such thing, it's need for the institutional gallery is yet to be determined. As such, the inverted central cathedral-like void that drops down through the building from the Entrance Pavilion, as well as the connected terraces and rooftops sloping down the site, are significant beyond mere public circulation. Left to breathe, these are the spaces of experience, and the 'living exhibitions' to come. They will be variously taken up in time, by tomorrow's artists who work out what to do with them, and by the institution as it fulfils its role to assemble the people.

Despite the resulting informality and invitation created by this strategy, actually because of it, Naala Badu is an eminently 'civic' building. By directing attention away from the architecture itself, and turning the focus and hence meaning of the art museum experience to the connections that it gathers – with the city, with the environment, with the people – it stages the possibility that through the arts, the work of the art museum (that work yet to be done) is a reconstitution of the civic contract itself. In response to curator Juliana Engberg's three As of 'Art, Artists and Audiences',[11] this is an architecture that knows who the project is ultimately for.

Above, from top: Howie Tsui's video work *Retainers of Anarchy* 2017 in the Neilson Family Gallery; Visitors engaging with Kimsooja's *Archive of mind* 2016–ongoing in the Isaac Wakil Gallery overlooking Woolloomooloo Bay

The building consequently resists or rather refuses a 'reading', especially from a distance, and seeks to constantly background itself. There is no formal facade, a fact that will grow more evident as the landscaping grows in, and it is not 'visual' in the sense of having an image to present to the public. Neither does it participate in the 'temple to culture on the hill' version of the museum that has dominated late twentieth-century architectural production. The architecture of Naala Badu, then, stands in marked contrast to the Art Gallery's recently refurbished original building, Naala Nura – transparent not closed, informal not formal, extensive not bounded, flexible not fixed, and so on – a design strategy that draws strength from the complementarity of the two buildings and time periods, while provoking alternative ways of not just encountering, but producing art. Interestingly, both buildings are more powerful and legible as architecture, when read against each other.

* * *

This should not surprise as the Art Gallery's new building now joins a lineage of SANAA's work that has explored these ideas over more than twenty years; projects such as the Rolex Learning Centre, Lausanne (2009), 21st Century Museum of Contemporary Art, Kanazawa (2004) and Grace Farms, Connecticut (2015). But perhaps more instructive is the extensive collection of SANAA's smaller galleries, projects including the N Museum, Wakayama (1997) and O Museum, Nagano (1999) in regional Japan that demonstrate the relation of continuity and context as fundamental to their conception of the art museum from their very first collaborative buildings.

The Yiribana Gallery loggia, featuring Lorraine Connelly-Northey *Narrbong-galang (many bags)* 2022, and the Pearl and Ming Tee Lee Plaza and Art Garden, viewed from Jonathan Jones's commission *bíal gwiyúṇo (the fire is not yet lighted)* in the final stages of construction, July 2024

Anthony Burke

For SANAA, 'Everything that exists in this environment is a participant in the conception of the architecture.'[12] In the simple rectangular form of the O Museum, the topography is reframed in section, by levitating the museum building above the ground and below the tree line, rendering the landscape fluid over and below, highlighting the three-dimensional quality of the landscape itself. Lifting up off the ground plane, the building reorients the gaze to the ancient Shoin (writing desk alcove) immediately adjacent and connects it to the mountain ridge behind. The architecture elevates both by stepping back into a role of experiential frame rather than figure. As a datum against which to comprehend the context, the building itself, along with the works of art on display in the gallery, supports the connection of place and history that this small art museum is ultimately all about.

The Kumanokodo Nakahechi Museum of Art, known as the N Museum, works similarly. Clearing a ground by the riverbank, a small white gallery box – that accepted gallery necessity – is encased within a fluid series of social spaces that condense and orient the visitor back to the ridges and the river and away from the building. It is as if the building seeks to hold the visitor suspended between the exhibition contained within and the extraordinary landscape without. Again, the view out from the building is superior to the view towards it, even while to Western eyes, the compositional elegance of white and glass forms seems to suggest otherwise. Naala Badu works on the same philosophy and spatial diagram, albeit with a more complex relationship to topography and scale.

* * *

Pushed to extend these ideas by the Sydney climate and topography, SANAA's approach to the Art Gallery's new building has interestingly been to partially embed the building into the landscape, thickening the surface layers above *and below* the terracing ground. In Sydney, we see the embrace of the topography as in Grace Farms (New Canaan, USA, 2015), but now over three or four levels, activating the project more determinedly in section with spaces extending vertically rather than just horizontally. The complexity of the building section, straddling park,

multilane traffic tunnel and land bridge, should not be underestimated.

The rammed earth wall deserves special mention in this context. As colour, as connection to country and context, as a compelling tactile spine; it silently communicates respect, knowledge and awareness of place to the visitor and, as an element, its stillness anchors the fluidity of the spaces around it while marking the passage of the visitors as they dance from the dark to the light and back again. Meanwhile, in the rough and most contained space of the Tank below, the darkness provides an atmospheric counterpoint to the rest of Naala Badu. Ultimately these features suggest it is not enough for a building to exist as a landscape; instead, as SANAA newly proposes, one must embed into it.

Again a response to place, another point of difference for SANAA in the Art Gallery's new building is simply the number of layers of space, material and light that gather around the visitor as they move into the space. In the Jining Art Museum (2019), a project by the Office of Ryue Nishizawa, a thin layer of highly polished glass is sandwiched between an undulating soffit above and the edge of a hard surface below; the edge of the building is super-thin and light. For Sydney, the staging of atmospheres works through many more layers to manage the harsher environment, both internally (intensive) and externally (extensive). From distant views and glimpses of roof edges, to overlapping planes of glass, fabric screens and plantings, transparent layers gently build up around the visitor in a continuum from the city to the Tank, leading ultimately to a powerful sense of immersion through layers of light, in spaces that hold their backs into the earth, and their faces to the sun.

The experience of Naala Badu is of overlapping and diffuse edges and atmospheres, just so slightly out of focus edges or transgressed boundaries and materials, suggested but uncommitted paths of travel (that literally slope), entries that are happened upon rather than announced, gentle layers of shade, texture and atmosphere that ebb and flow over you as you move around. The building offers not colour but hues that might change at any moment with a cloud passing

global art tourist. But how do you measure the value of an art museum today? The collection of art, the expression of the institution, the efficacy of its messaging, the capacity to attract more and more visitors?

Sydney as a backdrop to an artwork or collection raises even more interesting questions, taunting through the specificity of the local a global art market that defaults to universalising white walls that facilitate art anywhere. What happens when an art museum at this scale in the city gets location-specific? What sense of 'place' is pointed to? What kind of conversations arise?

Dorner constantly imagined and demonstrated how the museum could act as 'an organism of modern life'. Ultimately, this would mean 'it would not be a museum at all but a 'kind of powerhouse, a producer of new energies'.[14]

Fulfilling Dorner's vision in this sense, SANAA's architecture steps back and facilitates the encounter with the art by acting as the stage for this particular form of cultural theatre, as exactly that 'producer' rather than the (modernist) protagonist. In doing so, the architecture works not so much as an instruction for how to consume art, but as an offering to generate something new that assumes the audience itself completes the work, bringing us back to Nishizawa's idea of trust.

It is a wonderful idea that a precious cultural building, one that took a decade to bring into the world, with a hefty amount of public and private financial will as much as political determination would – could – 'trust' us, the visitors, to complete it, to make it work. As the visitors flow through the building without a prescribed route, eddying rather than marching in a conga line that the blockbuster is so used to creating, SANAA's building suggests there is no 'next in line', only 'where to next?'

overhead. And from within this cloudlike atmosphere, the city beyond and the art itself are the only elements that seem to come visually into focus while the building holds us in stasis between these two poles. In the words of Yuko Hasegawa, 'It is difficult to analyse the complexity, ambiguity and looseness concealed in the simplicity of SANAA's architecture.'[13]

* * *

In the context of global galleries, the Art Gallery's new building makes a powerful case for a new generation of cultural spaces that are distinctly 'after image', freed from the institutional grammar of the typical state-sponsored art museum, the old neoclassical version or the iconic fantasies of national caricature buildings that court the

Installation view of the Adrián Villar Rojas exhibition
The End of Imagination 2022 in the Nelson Packer Tank

Anthony Burke

Iwan Baan

A museum that fosters an ecological perspective: towards an intra-active architecture

Yuko Hasegawa
Translated by Darryl Wee

A museum that fosters an ecological perspective

In the 2020s, the effects of human actions on Earth systems, new structures of conflict, the gap between rich and poor, digitalisation and the introduction of AI will inevitably bring about paradigm shifts; the times are becoming increasingly uncertain and fluid.

Architecture since 2000 has tended to incorporate a program that reflects fluctuating conditions: it is flexible enough to accommodate people's behaviour and the purposes for which buildings are intended, as well as new, improvised and spontaneous uses. This entails the incorporation of derelict or abandoned spaces for alternative uses. Spontaneity is planned for mostly inside the building, and there are few examples of how it reflects and interacts with the context of the architectural site. It was a natural process for architecture to reflect the conditions of the site (topography, history, environment), which includes transforming the site and adapting it to the architecture. The way forward is an intra-active method that reflects the way elements are in a world where they are topologically entangled with each other.[1]

The architecture of the museum by SANAA in Sydney, New South Wales, is a new experiment – a development of its practice – that seeks to construct this sort of intra-active relationship. This is a project that intertwines the museum's collection, programmatic context, and the history of the place in an organic and intricate way with the creation of a new building connected to an old one, and a unique sloping site shaped not by the natural gradient of the terrain, but by the historical structuring of the site. What is experimental here is the way that SANAA conceived of the new building as a large ecosystem that encompasses the surrounding parks and elements of the Art Gallery of New South Wales, integrating culture, history, memory and the environment with each other, as well as its foray into architectural design in collaboration with environmental designers, to see how to approach this new building as an architectural structure within an intra-active relationship.

Let us delve a little deeper into one of the background factors underlying these experimental forays. I would first like to address the changing role of the art museum. Today, the museum is no longer a standalone building, but rather a symbol that points to the ecology of culture and the environment as a whole. Divisions within entities both large and small signal a desperate need for places where sharing and empathy can occur; necessity for a place where people can gather and talk is greater than ever, despite the underlying limitations of discourse, ideological debate and mutual understanding. It is a matter that goes beyond the simple, conventional interactions between art and the viewer to the dynamic among viewers themselves, involving the environment and history that surrounds them. The museum needs to be a place of sharing and empathy. This is how the museum in Sydney was conceived and the way in which architectural practice is moving towards the creation of relationships that encompass a multidimensional, organic, and participatory commitment to intra-action.

Decolonisation, immigration and minorities, gender issues, the cracks that appear in a state of excessive civilisation, and relationships with the voiceless – animals, plants and all things, including the air – present a complexity that cannot be overcome by conventional arguments. What is important here is a process of relearning: the reactivation of our sensors that perceive the world in a tactile way. Museums are places that enable learning through the five senses by exposing us to historical and current visual art (multimedia art). They are also places where we can train our sensors to respond to the ecology of everything that surrounds us.

Our senses are honed and refined by so-called 'wild' nature (which is never 100 per cent wild), by experiencing forests, oceans, and other natural habitats. The environment that surrounds us, however, is an amalgam of an incredible number of social, political, informational (including historical) and psychological factors, and art holds unprecedented importance as a mode of cognition and perception that allows us to access these factors in a subtle way. The question of how to establish a topological and intra-active relationship with the surrounding environment is one of the important missions of museums in the Anthropocene.

The first person in Naala Badu on opening day was six-year-old Morgan Gately and his mother, Deana Bell, seen here in the Yiribana Gallery viewing Yhonnie Scarce's *Death zephyr* 2017

Yuko Hasegawa

Multi-aspect relationships

An example of a building designed by SANAA that is keenly conscious of being an integral part of the landscape is Grace Farms, a cultural centre established by the Grace Farms Foundation in New Canaan, Connecticut. The building blends into the rolling forest and meadow landscape of Grace Farms like a river, beginning on a small hill and unfolding down over a long, gentle slope (the change in gradient is just over 13 metres), winding its way through many twists and turns. The glass space that emerges from the surface of the ground blends beautifully into the natural surroundings, forming a new kind of nature. Being inside the building also allows visitors to feel the organic shifts in the landscape that develop due to the difference in elevation and the curves of the building, creating an experience in which they feel at one with the landscape.

From the early days of SANAA's career, the idea has been present that architecture highlights urban planning and socially and naturally created landscapes, presenting new trajectories while maintaining the memory of these landscapes. SANAA's urban planning for the city of Oslo, for example, as well as its designs for the Louvre-Lens Museum north of Paris, intended to take a cue from traditional forms and graft them onto a new architectural DNA.[2] While there are exceptions, it is rare for inhabitants of a place to have a clear awareness of its topography and the distribution of buildings (planned or unplanned). These are familiar, everyday landscapes, and yet few people have a deep understanding of their structure, their relationship to history, and how they interact with engineering, the environment and social structures.

The Art Gallery's new building, Naala Badu, which opened in December 2022, was conceived in relation to the original building and the plan for the surrounding cultural zone, and is deeply related to the ecological, environmental design of the entire complex. This building represents a new step forward for SANAA, which has consistently been interested in the act of creating relationships through visual and experiential design, and has developed various kinds of experiments exploring the relationship between the urban landscape, the building exterior, and the bodies and actions of the people inside the building.

I once described SANAA's architecture in terms of the following characteristics: 1) 'four-dimensional architecture' that encompasses the temporality of events and actions, 2) flexibility, and 3) 'permeability' that reflects reality and does not seek to change it forcefully, but rather follows or intrudes on it like a shadow. Rather than planning

Above, from left: Grace Farms, New Canaan, Connecticut; The Louvre-Lens museum among the miners' houses of Lens, northern France **Opposite:** The 21st Century Museum of Contemporary Art, Kanazawa

A museum that fosters an ecological perspective

Yuko Hasegawa

A museum that fosters an ecological perspective

something in particular and bringing it to completion, SANAA adopts the stance of waiting to see what will happen, and what will appear on the spot.[3] Many of its buildings are based on the architects' reactions, on their sensitive, multichannel exposure to contemporary society and its environments. The Art Gallery of New South Wales is unique in that it is not simply built on sloping terrain, but on a topography or foundation of Sydney's history.

As SANAA describes it, 'it feels like the act of adding something to a part of the structure that has already been built'.[4] Here, the functional conditions are not schematised around the interior: rather, they are schematised and designed as a reflection of the relationship between the existing structure and the interior and exterior. The galleries are visualised from the outside as boxes, with each floor as the roof of another, and the footprint of each level visible. The works exhibited on the exterior walls of the boxes appear to form a vertical, zigzag three-dimensional gallery. The location of the cafe is also obvious. It is within this playful structure that the process of descending and circulating unfolds.

Forms that emerge out of experience: spaces that usher one into them

This relationship is difficult to see from the outside. The unique thing about the building of this museum is that while the design and program of the building itself is deeply related to the history and genetic makeup of the site, it cannot be seen from the outside (except from parts of the Woolloomooloo wharf), and it is difficult to grasp the form of the building while you walk through and experience it from the inside. While the difficulty of grasping the exterior initially appears to pose a problem for people seeking to explore the building from the inside, the individual experience of each person gives rise to an intrinsic grasp of the building's form.

The roof and the boxes are combined to provide openings in multiple directions, and the roof is extended as a kind of floor and balcony leading to the outside. As one moves up and down the escalators that connect the different levels at the centre of the building, various programs emerge, including a common space that encompasses a cafe and restaurant, galleries, a large video display using the walled surfaces of the boxes, and paintings.

This manifestation of the experience of the 21st Century Museum of Contemporary Art in Kanazawa, was realised in a kind of soft connection between interior and exterior, thanks to a roving perspective from a horizontal ground-floor structure that intersects three-dimensionally with the fixed perspective of a vertical structure. Regarding the horizontal connection between the town and the art museum, visitors become unable to separate the physical space of the building they are in from the landscape surrounding the building. Elements such as the room they are in and the corridors and cars seen outside the windows, form multiple layers of vision. In the Art Gallery, the architectural space from the upper to lower floors is visible through the central Atrium, along with the scenery outside. It is difficult to determine which floor and what room one occupies. In this sense, the situation here is analogous to the spatial awareness and sense of overlap at the 21st Century Museum of Contemporary Art in Kanazawa.

At Kanazawa, the gallery spaces as boxes come in more than ten different proportions, creating a sense of variety, while the corridors and other common (public) spaces are large in relation to the gallery area. Consequently, the corridors can be used for exhibitions and for creating spaces for reflection and conversation. The nature of the common spaces in the Art Gallery of New South Wales changes depending on their position, and these common spaces, including the walls of the boxes, are dynamically used as exhibition spaces. Each level has a balcony that leads to the outside space, opening up a free path for visitors that grants them a unique experience in terms of spatial shifts and flexibility. The view through the large glass walls is of an expansive natural and urban Australian landscape, while the exhibition program on multiple levels inside the building parallels the diverse ethnic and cultural backgrounds of the visitors.

The scale of the exhibition galleries and shared spaces is large, and SANAA was aware of the problem

The Aqualand Atrium, featuring artworks by Lindy Lee and Stanley Whitney (from left, lower wall) and Lisa Reihana (upper wall)

Yuko Hasegawa

of how to create a certain density of individual experience in terms of viewing art there. A curatorial decision was made to position sculptural partition walls (designed by Art Gallery staff) in larger galleries so they would be divided in a softer manner, while a conscious effort was made to avoid giving visitors a scattered, disorganised impression.

A clear program is featured in the new Sydney building: the entry level houses the Aboriginal and Torres Strait Islander art collection, the permanent collection gallery is found on lower level 1, the temporary exhibition galleries and the gallery for time-based art are on lower level 2, and the sculpture gallery is located in the common space. Artworks are arranged in a way that does not give the impression of large sprawling installations; they are housed within spaces created by the vaulted roof and boxes, designed to continuously draw the attention of visitors.

The elevation of exploration: bridges of connection

The highlight is the Tank space on lower level 4, where SANAA preserved one of the original tanks and installed a spiral staircase, leaving the rest of the existing columns intact. This bold transformation expanded the space and imbued its former function as an industrial building with a sense of depth and temporality akin to that of an archaeological site, transforming it into an enigmatic labyrinth that can capture the imagination of artists.

The disparity between this gravity and the lightness of the first entry point and the entry pavilion parallels the depth of the experience to be found in the variations in the building elevation, as well as the psychological process of the audience as they explore the place.

Here, one finds a sense of natural connection, as if the original topography had summoned up each level of space, the elaborate engineering that connects outside and inside, and environment-building aspects such as the large glass canopy built over part of the land bridge that serves to link the new building with the original building, Naala Nura, and the urban structure of the city. With these major elements in place, visitors partake in an experience where artworks mingle with and permeate their bodies within a multifaceted perspective incorporating information about the changing urban landscape and the memory of the place. The freedom of movement between interior and exterior spaces, combined with the diversity of artworks and media interfaces on display, make the Art Gallery a museum that grants visitors access to intra-active experiences.

SANAA refers to an awareness of the need to create environments and landscapes rather than buildings. The flooring and walls that reflect local materials and colours, as well as the commissioning of art for both interior and exterior common spaces, demonstrate that Art Gallery staff are working toward the same goal. The future-oriented stance of the modern and contemporary art museum is shown here, as it moves beyond dichotomies and embraces contradiction, change and organic topological mixtures as its new strengths.

Acknowledgement of Country is the act of making a statement about what a place represents to Indigenous Australians during ceremonies and events. The location and structure of the museum also acknowledges the history of the Aboriginal ownership of the land, as well as the history of modernity. The multilayered memory of this land has become part of a circular ecology and visitors to the museum are made acutely aware of this.

Aerial view of Naala Badu looking towards the Royal Botanic Garden, Sydney Opera House and Sydney Harbour Bridge

A museum that fosters an ecological perspective

Yuko Hasegawa

From dream to reality: building the Sydney Modern Project

Sally Webster

From dream to reality

On an unseasonably hot day in November 2019, a crowd gathered on the roof of two disused Second World War oil tanks on unceded Gadigal Country to celebrate breaking ground for the Art Gallery's new building, Naala Badu. This last phase of the Sydney Modern Project would give concrete form to SANAA's design and realise the Art Gallery's long-held dream of expansion and institutional transformation.

The site for the new building was a relatively small parcel of land. Despite its location close to the centre of Sydney, it had remained an outlier from the city's constant cycle of urban renewal. Skirted by harbour and garden, it was an accretion of natural and built forms, including a concrete land bridge that partially covered the freeway below, two disused Second World War oil tanks and a remnant sandstone escarpment.

SANAA's design played on the concept of transition 'from man-made Botanic Gardens and Domain to the wild and natural sandstone escarpment of Woolloomooloo Bay',[1] in response to the 20-metre level difference between two of the site's boundaries – Art Gallery Road and Lincoln Crescent on the Woolloomooloo foreshore. Possession of the site was split between three parties: the Art Gallery (6%), Roads and Maritime Services (37%) and the Royal Botanic Gardens and Domain Trust (57%). The site also included a sub-lease attached to a zone below the concrete land bridge and a number of easements.

Agreement on a land tenure strategy was imperative: to enable negotiations to commence on legal deeds, to confirm arrangements during construction, and to provide certainty for the Art Gallery in the future management of the expanded campus. Negotiations were complex and time-consuming. Buoyed by the goodwill of the parties involved and collective acknowledgement that this was a once-in-a-generation project, the deeds were finally executed in late 2018. In September 2019 Richard Crookes Constructions (RCC) was awarded the construction contract.[2]

By December 2019 demolition had commenced and the hands of construction workers began to imprint themselves on site. A pump room and substation at the eastern corner of the site were demolished along with the roof and internal column structure of the northern tank, which would eventually be converted into back-of-house areas and a loading dock. This opened up access to the site from Lincoln Crescent and allowed soil and fill to be removed and piling works to commence. Every part of the site was stripped bare, and gradually – over the course of the hot, dry months of that summer under intermittent smoke from bushfires ravaging the east coast – its secret history was revealed. Discrepancies between as-built documentation and built structures, non-existent waterproofing membranes, contaminated soil, poor rock quality, an entanglement of high-voltage cables with tree roots and oil seepage in the southern tank were all uncovered.

The Sydney Modern Project Delivery Team was only just mobilising during these early months and although latent conditions had been anticipated and commensurate budget allocations made, the extent of the issues needing resolution brought the role of the team into sharp focus.[3] It was a hard and fast start to ensure there was timely consideration of issues and no time lost in the construction program.

The Art Gallery's art commissioning program was also gaining momentum at this time. Simryn Gill had been commissioned to record the transformation of the campus and Richard Lewer to record the human element of the project. Site access was essential for the artists. There was too much risk to the program in these early months for any works to be stopped, so a plan had to be negotiated. Despite some initial reservations, RCC provided safe passage for the artists. It was the first of many times when 'no' may have been the easiest answer, but the construction team found a way to support the Art Gallery's curatorial ambitions. A Canary Island palm was taken on a detour after being removed from the site, to be laid out in front of the Art Gallery's original building, Naala Nura, where, under a makeshift shelter, Simryn Gill rubbed its 26-metre-long trunk and fronds with graphite. Meanwhile Richard Lewer took up intermittent occupation of the site sheds – talking to, drawing and painting the workers.[4]

Sally Webster

Above: The Sydney Modern Project groundbreaking ceremony, November 2019 **Opposite:** Aerial view of the construction site during the first COVID lockdown, May 2020

The ambition of the project was inherent in SANAA's design. Its architecture was grounded in the context of the site and the building's role as an art museum:

> Circulation both inside and out follows organic paths that resonate with the existing terrain and surroundings. By integrating art, the topography of the site, and the surrounding landscape, we hope to create an art museum experience that is distinctive to Sydney.[5]

While RCC was committed to a delivery program and budget, it would be the task of the Sydney Modern Project Delivery Team to ensure SANAA's design intent was realised in the built form. This assessment could be made only by SANAA's founding principals, Kazuyo Sejima and Ryue Nishizawa, as the building took shape. It was unimaginable in the last months of 2019 that a pandemic would render travel impossible and mean their first site visit would not be until July 2022, when the building was one month from practical completion.

By early 2020 the reality of the global pandemic was starting to emerge. If there can be any serendipity found in restrictions following the spread of COVID-19, it was that the most disruptive and noisy outdoor works were occurring on site as the Art Gallery closed its doors and the city went quiet. When Australia's international borders closed in late March, SANAA's Asano Yagi, who up until that point had been travelling between Sydney and SANAA's Tokyo studio, made the decision to remain in Sydney. It would be close to a year before her return to Tokyo was possible.

The key structural materials of SANAA's design were steel, glass and concrete. With the pandemic beginning to impact the global supply of goods, the risk of not getting materials to site was elevated. By a stroke of good fortune RCC had decided to procure structural steel from South Australia, so that when the first of two tower cranes was installed in July 2020 work commenced as scheduled on the steel 'skeleton' of the building. But the proprietary product Nippon Steel had been specified by SANAA for the structural decking of the roofs.

Manufactured in Japan, it was a material familiar to the architects from a number of their projects and was to be used throughout the public spaces of the building. Its distinctive trapezoidal sheet finish would be exposed and was integral to bringing lightness to the roof structure. But Nippon Steel was not readily available in Australia and an alternate local supplier needed to be found. There was no comparable product available here and although there were several off-the-shelf alternatives, they did not match its aesthetic standard. While sourcing the material within Australia lessened the supply-chain risk, it took months of design development and product testing before a custom-made profile was made that satisfied SANAA and met the required technical specifications.

The glazed facade was a key expression of SANAA's architectural intent. It allowed the building to sit lightly in the landscape while simultaneously anchoring it to the site. Risks around the quality and appearance of glass are not unusual in construction projects and are generally mitigated through factory visits. The glazing was being manufactured in China, which was firmly isolated due to the continuing pandemic, so travel was out of the question. SANAA and the project team relied on samples being sent to SANAA's Tokyo office as well as prototypes being built on the construction site. Contacts were identified in China to undertake factory inspections and report back. This could be a slow process if the reports required translation into English. Risks remained high even once the glass had been manufactured. The 14-metre glass mullions for the eastern facade of the building were too large for a standard shipping container, so custom-made cradles that would attach externally to the ship's deck had to be built. The 108 curved sheets of form-cast glass with inlaid ceramic fritting that comprise the roof of the Welcome Plaza canopy needed to be shipped four per container, each one resting on a steel support. COVID-19 was causing significant disruption in Chinese ports and again contacts in China were asked to visit and report on shipping progress. Once the glass was en route, RCC closely tracked each ship until its safe docking at Botany, from where it was transported via road to the site. Installation was also high risk and required bespoke

lifting equipment. It was a huge milestone when the glazed facade was complete and the building enclosed.

The delayed supply of lightweight concrete was a further complication that arose as a result of COVID-19. Most of the building had been pulled back from the land bridge covering the Eastern Distributor to achieve a restricted weight-load. However, SANAA's design required a small portion of the building to rest on it; and for the roof and floor structures of this area, as well as those supported by the oil tank, lightweight concrete was specified – not the standard concrete mix used throughout the rest of the building. While the construction industry was challenged by the consequences of the pandemic it had not slowed pace. Infrastructure works were continuing throughout the city, with an associated demand for high volumes of standard concrete. Lightweight concrete required a special mix and dedicated machinery, and construction would be significantly slowed without it. It was a tense waiting game for a concrete plant to become available to manufacture the mix.

Under the terms of the contract, design details were reviewed, discussed and signed off by Infrastructure NSW on behalf of SANAA and the Art Gallery. Because

of the pandemic, the building industry was working under new configurations with unfamiliar expectations, and the day-to-day functioning of the Sydney Modern Project Delivery Team took on a distinct intensity. There was substantial creative tension keeping detailed design development on track with the construction program. In daily online meetings the team examined every element of the building, and despite the relentless schedule, a stable rhythm developed. The outside world receded while the team worked in this strange and isolated state – as did the prospect of Kazuyo Sejima and Ryue Nishizawa visiting the site.

SANAA's design palette for the building was neutral, to support the display of art. Within this neutrality the architects wanted to use local, handmade and other natural materials to create subtle colours and textures to achieve spaces that were warm, familiar and connected to site. The concrete floors, the limestone cladding of the art pavilions, and the rammed earth wall needed to complement each other in materiality and tone. For the SANAA team in Tokyo, it was hugely challenging to make decisions based on images and written descriptions of how each of these finishes performed in an Australian

Naala Badu under construction, March–June 2022

Sally Webster

climate and light. Terms such as 'warm-toned' – used to describe the colour of the concrete floors in the public spaces – lost meaning without the context of the site.

The limestone for the facade of the art pavilions was sourced from a quarry in Portugal. A Portuguese member of SANAA's Sydney Modern Project team, who had returned there from Tokyo once the pandemic took hold, was able to select the 'bench' to quarry. Most of the 52,000 pieces required to clad the pavilions were cut to size prior to shipment, with bespoke pieces, capping and door cladding cut in Sydney. As with the glass, the limestone came to Sydney by sea, with the final shipment stalled by the container ship *Ever Given* blocking the Suez Canal.[6] A high proportion of the workers responsible for laying the stone resided in the Canterbury-Bankstown Local Government Area, which was subjected to the toughest lockdown mandated by the NSW Government. Considerable disruptions to work were endured and needed to be 'made up' once restrictions were eased.

As the building form emerged, increasing numbers of skilled workers across a multitude of trades started to inhabit the site. There was resonance for the Art Gallery in the idea of a building dedicated to artists having significant elements that were 'handmade'. The most emphatic expression of this quality in the building was a rammed earth wall tracing the original topography of the site. It was a key finish in SANAA's material palette for the building, stretching over 250 linear metres and running across two levels. In SANAA's words,

> [it] emerges from the ground at the southeast extremity of the site, continuing across the landscape through the interior and out to the northwest where it disappears into the earth again. Its appearance is stratified and follows the current landform to serve as a memory of the changes and manipulations of the site throughout the years.[7]

SANAA held no expectation of perfect uniformity in the finish, the appeal would be the natural and 'handmade' texture. The look and feel of rammed earth in a gallery interior was hotly debated: materials that allowed more control to be exerted during the making process, such as concrete, were put forward as alternatives. The Art Gallery remained steadfast in committing to this key element of the building, confident – after working with SANAA for close to five years – of the extraordinary quality the rammed earth would bring to the building when complete. The path forward, however, remained high risk. It was a challenge to source a supplier from the relatively small number of contractors who were themselves relatively small entities working primarily at a small scale. Commercial constructions at a large scale, such as the long, sweeping curve that would achieve SANAA's design intent, had never been attempted by these contractors. With no end to the pandemic in sight, there was potential for issues with supply chain and logistics. Once again, samples were exchanged between Sydney and Tokyo and prototypes built on site to support decision-making about the treatment of edges and the location and type of art-fixing points. Different sands were prototyped to get the right colour and consistency. Most of it eventually came from the Sydney region, with a small quantity of red sand sourced from Wagga Wagga in the south-west of New South Wales. Once construction of the wall commenced, constraints on site meant the material needed to be pumped into the formwork by air-driven handheld rammers and its construction had to match the construction sequence on site. Use of this methodology would mean the final look of the wall would be revealed only past the point when any rectification was possible. Over eighteen months the long, slow sweep of the wall emerged as it became embedded in the building, exuding 'a softness and a warmth and a timelessness ... that just helps a building settle in'.[8]

The pandemic continued to impact activity on site, particularly social distancing requirements. RCC were forced to modify construction sequencing to maintain forward momentum and shift how the workforce was managed on site. While this type of agility was demanding, works were at least progressing. Then, over eleven days in late July 2021 construction was paused on site as a result of the NSW Government ordering construction

Installation of the limestone bricks

From dream to reality

sites in Greater Sydney to close.[9] In the long history of the project, this was the first time work had stopped. When the site reopened, capacity was restricted to half the peak workforce numbers. Although by the end of September the NSW Government had lifted this cap, workers remained restricted to one person per four square metres until December, in line with social distancing requirements. COVID outbreaks in the workforce continued and had an impact on the pace of works. To accommodate fewer workers on site, multiple work-fronts were opened to prioritise activities linked to the critical path. To the untrained eye progress was impossible to detect and a finishing date of 2022 began to feel ambitious.

By the end of 2021 the workforce cap on construction sites had been lifted. The roof (and highest point of the building) was complete, and a small ceremony was held in November, two years after groundbreaking, to celebrate 'topping out'. As the pandemic receded there was optimism for a clear run to building completion.

Unanticipated was the number of rainy days Sydney would experience over the first half of 2022, the fourth rainiest year-to-June since 1859.[10] A significant portion of works in the final stages of construction required dry weather. The unusually wet conditions demanded design changes to the waterproof membranes on the roof terraces to enable installation to proceed despite rain. Each of the suckers gripping the 108 curved sheets of form-cut glass as they were craned into place on the Welcome Plaza canopy needed to be dry. So too did the suckers lifting the final panels into place on the glazed facade. The final concrete pours needed dry weather to cure. The external landscaping works, particularly outside the existing building, were mired in mud and by the time the earth had dried out enough to recommence work, more rain had fallen.

The final months of construction were gruelling. In April 2022 the Art Gallery had announced the building would open to the public on 3 December 2022 and the pressure to keep on schedule was immense. The Art Gallery had its own exhibition schedule and while external works continued, staff began to inhabit the

building and bring life to the ambitious commissioning program and exhibitions.[11] RCC demonstrated the same agility as it had during the COVID-19 lockdowns and kept works progressing during the final months. But it was much more demanding this time around. After two years living and working during the pandemic everyone was tired. A superhuman collective effort was needed for the final push to get the building finished.

In July 2022 Kazuyo Sejima and Ryue Nishizawa made their first site visit since the groundbreaking ceremony in November 2019. It was a moment of reckoning, followed by relief in the acknowledgement that their ambition had been realised. A short list of comments followed the visit and in August SANAA's entire staff of 61 travelled to Sydney to see the building. After three years combatting unprecedented events the building opened on 3 December – on time and on budget.

At the end of a building project a final account by quantum of the material – steel tonnage, cubic metres of concrete, tonnes of material removed from site – is often used. That is not the story of the Sydney Modern Project. This story rests with the workers who inhabited the site through bushfire smoke, a pandemic and endless rain; with the consultants who spent years detailing every aspect of the building; with the Sydney Modern Project delivery teams and with the architects who offered us 'a future to dream into'. Collectively and individually, whether undertaking complex or simple tasks, it was their hands and minds that realised the ambition of the Sydney Modern Project. Richard Lewer's suite of paintings and drawings paying tribute to this human element ensures their story is now part of the history of the Art Gallery.

SANAA onsite, July 2022. From left: Andrej Stevanovic, Sally Webster, Michael Brand, Kazuyo Sejima, Ryue Nishizawa, Yumiko Yamada and Asano Yagi.

Sally Webster

Richard Lewer *Onsite, construction of Sydney Modern which resides on the lands of the Gadigal of the Eora Nation* 2020–21 (multi-panel painting and selected drawings)

From dream to reality

Sally Webster

Iwan Baan

Photo essay index

Photo essay I

(pp 37–71)

Aerial view of the roofs and terraces (detail)

Aerial view of the Art Gallery campus, July 2024, featuring Jonathan Jones *bial gwiyúno (the fire is not yet lighted)*

Aerial view of Naala Badu looking towards the Domain and the city

View of the Rosie Williams and John Grill Terrace

Aerial view of Naala Nura and Naala Badu looking towards Woolloomooloo

The Pearl and Ming Tee Lee Plaza and Art Garden from Art Gallery Road

View of the Yiribana Gallery loggia and the Pearl and Ming Tee Lee Plaza and Art Garden

Looking towards the Yiribana Gallery loggia

The Pearl and Ming Tee Lee Plaza and Art Garden, featuring Francis Upritchard *Here Comes Everybody* 2022

The Guido and Michelle Belgiorno-Nettis Terrace, featuring Yayoi Kusama *Flowers that Bloom in the Cosmos* 2022

Visitors dining on the Andrew and Jane Clifford Terrace overlooking Woolloomooloo

Limestone bricks and canopy of the Guido and Michelle Belgiorno-Nettis Terrace

Aerial view of the roofs and terraces

View of Naala Badu from Woolloomooloo

View of the Andrew and Jane Clifford Terrace looking towards the naval base at Woolloomooloo

Exterior view of the Paradice Foundation Learning Studio with the Yiribana Gallery above

The Rosie Williams and John Grill Terrace, featuring Yayoi Kusama *Flowers that Bloom in the Cosmos* 2022

Aerial view of Naala Badu looking towards the Domain and the city at dusk

181

Photo essay II

(pp 89–123)

Stairwell entrance through the rammed earth wall, lower level 1

The Susan Wakil Pavilion, looking towards the Pearl and Ming Tee Lee Plaza and Art Garden

The Susan Wakil Pavilion, and the Gallery Shop designed by Akin Atelier

View from the Yiribana Gallery loggia, featuring Lorraine Connelly-Northey *Narrbong-galang (many bags)* 2022

View of the Aqualand Atrium, featuring Lisa Reihana *GROUNDLOOP* 2022

View of the restaurant and Aqualand Atrium, featuring John Olsen *Spanish encounter* 1960

View of the restaurant and the Patricia Ritchie Stairs leading to lower level 2

The curved roof on lower level 1 looking towards the restaurant

View to the Susan Wakil Pavilion from lower level 1

A children's guide and young visitors study Takashi Murakami *Japan Supernatural: Vertiginous After Staring at the Empty World Too Intensely, I Found Myself Trapped in the Realm of Lurking Ghosts and Monsters* 2019

The Isaac Wakil Gallery on lower level 1 overlooking Woolloomooloo Bay, featuring Ernesto Neto *Just like drops in time, nothing* 2002

Installation view of the *Making Worlds* exhibition in the Isaac Wakil Gallery, featuring works by (from left) Nina Chanel Abney, Mira Gojak and Gail Mabo

Installation view of the *Dreamhome* exhibition in the Ainsworth Family Gallery on lower level 2, featuring Michael Parekōwhai *Te Ao Hau* 2022

View from the Susan Wakil Pavilion, featuring Betty Kuntiwa Pumani *Antara* 2017

The Aqualand Atrium, featuring works by Lindy Lee (lower wall) and Lisa Reihana (upper wall)

The Rothwell Stairs in the Nelson Packer Tank

View of the Nelson Packer Tank

The Aqualand Atrium, featuring works by Lisa Reihana (above) and Betty Kuntiwa Pumani (right)

View towards the Susan Wakil Pavilion overlooking the Aqualand Atrium, featuring Takashi Murakami *Japan Supernatural ...* 2019

Photo essay III

The glazed wave-form canopy

The reflecting pools designed by Kathryn Gustafson on the forecourt of Naala Nura, looking towards Naala Badu

View of the Pearl and Ming Tee Lee Plaza and Art Garden, featuring Francis Upritchard *Here Comes Everybody* 2022

SANAA-designed seating in the Pearl and Ming Tee Lee Plaza

Aerial view of Naala Badu

View of Naala Badu overlooking Woolloomooloo with landscape designed by McGregor Coxall

The Guido and Michelle Belgiorno-Nettis Terrace overlooking Potts Point and Woolloomooloo

SANAA-designed seating on the Andrew and Jane Clifford Terrace

Visitors moving between terraces

View to the restaurant and Susan Wakil Pavilion above

The gardens next to the Ainsworth Family Gallery with the Yiribana Gallery above

The Roy and Patricia Medich Sculpture Garden on lower level 2, featuring works by Sanné Mestrom (foreground) and Justene Williams

The Nelson Meers Foundation Hall on lower level 2

The Hua Family Spirit House Garden leading to Lee Mingwei's *Spirit House* on lower level 2

View to the Rosie Williams and John Grill Terrace with Quay Quarter Tower designed by 3XN Architects beyond

The Pearl and Ming Tee Lee Plaza

View of Naala Badu and the Naala Nura forecourt on Art Gallery Road

Naala Badu at dawn

Architecture in focus

Adaptive reuse

The engineers who designed the vast fuel bunker for the naval fleet at Garden Island during the Second World War could not have imagined that eighty years after it was constructed in 1942, it would become part of a new art museum building. The bunker consisted of two oil tanks set into the sandstone ridge extending along the Domain near the Sydney Harbour foreshore and covered by a grassed concrete platform. Emptied and decommissioned in the 1980s, they sat disused for decades, hidden from public view.

The choice of this site for development, to the north-east of the Art Gallery's original building, provided the opportunity to incorporate the tanks into the design of the new building. Architects in the final stage of the international design competition in 2015 were asked to consider how parts of the structure could be retained, interpreted and/or used for a new purpose.

Through the design development phase, SANAA and the Art Gallery decided to retain the entire southern tank (while stripping out the northern tank to accommodate a loading dock and other back-of-house functions) and to honour its spatial characteristics – 2200 square metres with 7-metre-high ceilings, and 125 columns with elegant, chamfered corners in a 4-metre grid. After a memorable first visit in late 2017, when the architects entered through a small hatch and climbed down scaffolding in gumboots to the watery floor of the tank below, they committed to transforming the tank into an art space with as little intervention as possible.

The sensory impact of the tank resonated deeply with everyone who visited in the early days of the project. The scale, materiality and cathedral-like acoustics of this hidden secret were remarkable. Its patina-streaked walls and columns, and tree roots that miraculously continued to grow inside, revealed the living fabric of the space. Both architect and client knew it was something special to be shared with visitors and artists. This unique, historically significant example of wartime engineering, described by SANAA as 'Sydney's treasure', would find a new purpose fuelling art and creativity.

As well as the exciting design possibilities, this adaptive reuse of the site's post-industrial infrastructure contributed to the building's 6 Star Green Star design rating – the first awarded to a public art museum in Australia.

Located on the building's lowest level, the Tank supports the Atrium and an art pavilion dedicated to major exhibitions. To connect the two levels, SANAA designed a spiral staircase that slowly reveals the dark subterranean world to visitors as they descend. The white steel stair weighs almost 20,000 kilograms, with an 11-metre central column, 43 treads and three full rotations. Following 700 hours of fabrication in Adelaide, it was divided and transported by truck to Sydney before being lifted by crane and installed through an aperture cut through the Tank roof.

As SANAA's major architectural intervention in the Tank, the spiral staircase beautifully articulates its transformation from disused fuel bunker to contemporary art space. Ten replacement columns, a new polished concrete floor and lighting tracks are the only other signs of modification. Argentine-Peruvian artist Adrián Villar Rojas was awarded the inaugural Tank commission for the building's opening in December 2022. When he first visited, he 'understood with all my senses the power and potential of this underground realm with all its layers of time, materials and history.' His five massive sculptures set in darkness under moving lights, titled *The End of Imagination*, invited us into an equally intense encounter.

Above and right: The Rothwell Stairs being lowered into the Nelson Packer Tank, September 2021 **Opposite:** Visitors at Adrián Villar Rojas' exhibition *The End of Imagination* 2022

Lee Mingwei's *Spirit House*

Art and architecture are directly connected in Lee Mingwei's Sydney Modern commission, *Spirit House*, which is embedded into the fabric of the new building.

Collaboratively designed by the Taiwanese–American artist and SANAA, the work's small domed room is located at the northern end of the sweeping, rammed earth wall. Visitors follow an outdoor garden path on lower level 2 and enter *Spirit House* through a door cut into the wall. Inside the space, which is also made of rammed earth, visitors encounter a bronze sculpture of the Buddha sitting in meditation, his palms facing upwards in *abhaya mudrā*. Created for the commission by Taiwanese master sculptor Huang Hsin Chung, the Buddha is seated beneath an oculus through which a shaft of light falls.

The Art Gallery's senior curator of Asian art, Melanie Eastburn, said that while *Spirit House* continues Lee's focus on participatory works of human and spiritual connection, it is unique to the Art Gallery and was inspired by his first visit here in 1999, when Lee felt drawn to a Sui dynasty (581–618 CE) Chinese Buddhist sculpture from the collection.[1] Then at a crossroads in his life, Lee asked the Buddha to guide him on his journey. With his wish fulfilled some years later, he returned and revisited the figure to express his gratitude, as well as the hope that its spirit would guide another project. Lee's experience grew into the concept that has become *Spirit House*.

The result is an intimate experiential installation where Lee invites viewers to take a personal journey or be open to a spiritual encounter. Once a day, at an unspecified time, a smooth pebble wrapped in rattan is placed in the Buddha's hands. The visitor who finds such a stone is welcome to take it with them. Lee has carried a similar wrapped stone on his travels for years and wanted others to be able to share the experience. Visitors who choose to take a stone are also invited to return to the Art Gallery and share the story of their own journey.

Lee recalls an alchemical moment at a design workshop in Tokyo when SANAA co-founder Kazuyo Sejima asked how he envisaged the installation. Lee described a womb-like space. 'As I was talking, she was drawing on a napkin, and she said, 'Mingwei, is this okay?' I burst into tears. She had sketched the design in that time, and then everything came together.'[2]

Translating the design into built form, however, was anything but simple. A domed roof made of rammed earth was the first of its kind in Australia, and engineering and construction innovations helped realise the grace and elegance of the architect and the artist's intent to create a nurturing place for reflection, contemplation and gratitude.

'The subtle generosity of Lee Mingwei's work endures beyond the moment of encounter,' Eastburn said.

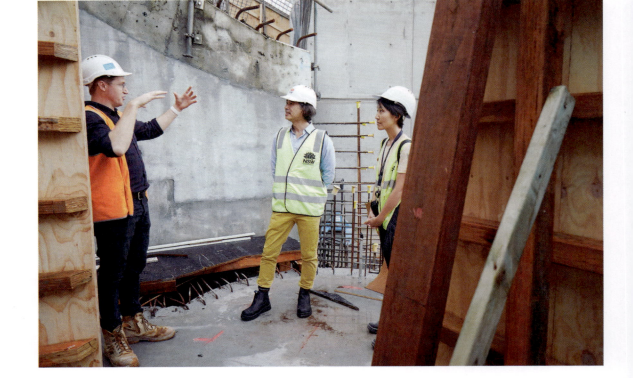

Above: A stone is placed into the Buddha's hands during the blessing ceremony conducted by representatives from the Nan Tien Temple, Wollongong, November 2022 **Right:** Artist Lee Mingwei (centre), senior project engineer Jesse Moss from Richard Crookes Constructions, and SANAA's senior designer Asano Yagi during the construction of *Spirit House* **Opposite:** View to the entrance of *Spirit House*

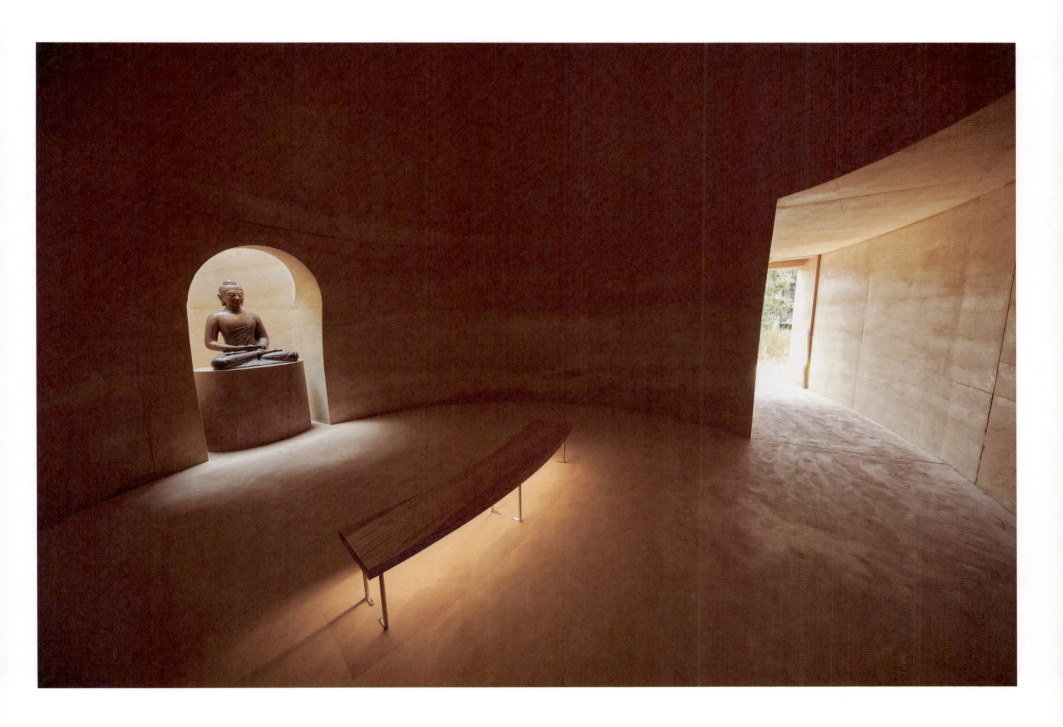

Rammed earth walls

Two rammed earth walls totalling 250 metres in length and up to 6 metres high are a highlight of SANAA's design of the Art Gallery's expansion. The upper portion of the wall is encountered inside and outside the building on lower level 1. The second portion is a 150-metre-long sweeping wall on the floor below, which starts outside and runs inside through that entire level before ending outdoors, with Lee Mingwei's *Spirit House* commission (see pp 35, 188) built into its northern end.

The material evokes a strong sense of place, connecting the building to the site's topography, cut into a sandstone escarpment, and to the original building's sandstone facade. The walls form two arcs that give warmth and softness to the new building, and complement the light-coloured limestone walls of the art pavilions.

Rammed earth is a new material for SANAA. It's also not traditionally used in museums for art display, so designing it to form an exhibiting wall of this scale was ambitious. Despite the challenges, the Art Gallery and architects were committed to realising the design intent: to create a strong connection between interior and exterior spaces, anchor the building in its surroundings, and be environmentally friendly.

Prototyping was required to achieve the colour and texture that best evoked Sydney sandstone. With the mix agreed, the bulk of the sand was sourced from the Sydney region with some red sand from regional New South Wales. 'By using materials and colours similar to [the] originally existing building,' said SANAA's co-founder Kazuyo Sejima, 'we aimed to make the entire museum feel like a new topography harmonizing with its surroundings.'[1]

Over a period of eighteen months, John Oliver and his team from Rammed Earth Constructions from Queensland handcrafted the walls on site, the biggest they had made, compacting and ramming the sand to achieve the refined layers that are powerfully resonating with visitors.

The addition of rammed earth to SANAA's material palette of glass and limestone creates a distinctive backdrop for the display of art, at a grand scale not achieved before in a public building. Oliver said, 'I really love its long sweeping expanse and the natural flow of layers. Rammed earth has a timelessness about it. It sets a tone for the building and makes visitors feel relaxed and welcome.'[2]

Above: Inspecting a prototype of the curved rammed earth wall
Right: The rammed earth wall under construction **Opposite:** The curved rammed earth wall on lower level 2

Sustainability

In 2018, when the Art Gallery of New South Wales became the first public art museum in the country to achieve the highest environmental standard for design – 6 stars awarded by the Green Building Council of Australia – it set a new benchmark for what is possible for cultural institutions.

'The Art Gallery of NSW provides a blueprint of excellence for other public arts spaces to follow, illustrating how, through sustainable design, architectural and cultural landmarks can be created that inspire in myriad ways,' said the Council's chief executive Romilly Madew when announcing the rating for the expansion.[1]

This result, representing 'World Leadership' in the rating scale, exceeded the Sydney Modern Project's original 5-star goal and is a testament to SANAA's design and the Art Gallery's commitment and multifaceted approach to sustainability, integrated into the project from its inception. Environmentally sustainable design principles were embedded in the brief for the international design competition that commenced in 2014. Evaluation criteria focused on an innovative response to all aspects of sustainability, particularly those relating specifically to the design of art museums – typically big energy users needing to maintain strict climate controls for the long-term preservation of collections.

In the Art Gallery's case, that meant achieving a fine balance between its responsibility as custodian of the $1.9 billion state art collection and its need to reduce the impact on the environment. Research on the best practice of leading art museums internationally proved valuable, enabling us to translate sustainable principles into reality in the building's design development phase.

SANAA's scheme locates art pavilions at different levels across the site. The arrangement of these climate-critical spaces provided a new way to think about how conditions could be managed. Each layer of the building is calibrated around an inner core. Interstitial and circulation areas radiate out from the pavilions, with environmental conditions incrementally relaxed and aligned to how the spaces are used and curatorial intent.

All the building's energy needs are provided by renewable power, with more than 10 per cent generated by 735 solar panels covering the roof of the Entrance Pavilion, which also features an airlock. Inside, the design maximises daylight in circulation spaces, with extensive use of LED lighting in gallery spaces.

Another contributing factor to the 6 Star Green Star design rating – extended to a 6 Star Green Star Design & As Built rating in December 2023 – was the adaptive reuse of a former Second World War naval fuel-storage tank as an art space. Repurposing of existing structures significantly reduced embodied carbon relative to a standard building. This equated to a saving of more than 3000 tonnes of carbon dioxide for the Tank alone.

A rainwater harvesting system collects water from all roofs and trafficable terraces for reuse in cooling towers and irrigating over 8000 square metres of green roofs and gardens. The award-winning landscape design by McGregor Coxall has improved the site's biodiversity with over 50,000 Australian native plants and a 70 per cent increase in the number of trees.

Above: Native plant beds Right: Landscape architect McGregor Coxall's rooftop garden above the Nelson Meers Foundation Hall on lower level 2 Opposite: Green roofs and photovoltaic panels on the Susan Wakil Pavilion roof

Engineering

SANAA's light and expansive design of the Art Gallery's new building belies its technical complexity. The site chosen for the project, adjacent to the original building, encompasses a steep escarpment to the north-east of the Domain parkland overlooking Sydney Harbour. It's a beautiful but challenging location straddling a land bridge over one of Sydney's busiest motorways. Adding complexity were two vast decommissioned naval fuel tanks.

SANAA's vision saw these existing structures as both a constraint and an opportunity. The new building is formed by interlocking art pavilions nestled into the landscape over five levels, resting lightly on the land bridge and the tanks. SANAA's design guides visitors in an understanding of place – roofs are turned into gardens and terraces, and the visitor experience is expanded through traversing gallery spaces via indoor or outdoor routes. This architectural ambition to create a new type of art museum experience unique to Sydney had to be equally matched by the project's engineers. 'Engineering-led solutions were at the heart of this project from the very beginning ... providing clever and effective solutions to realise the design and functional intent and potential of the site', said Andrew Johnson, principal at Arup, who led the multidisciplinary engineering team on the Sydney Modern Project from the architectural competition stage through to completion.[1]

Positioning of the building on the land bridge was a careful dance between building function and massing the load-carrying capability of the existing structure. Close collaboration with the architects combined with detailed structural analysis minimised column sizes and depth of structural framing, while eliminating bracing in the glass walls of the art pavilions and the Welcome Plaza. Extensive use of composite steel and lightweight concrete floor and roof structures was vital to keeping the loads within the design constraints of the fuel tanks and land bridge. This eliminated the need for strengthening of the land bridge structure, which would have required disruptive closures of the motorway below.

Nonlinear response history analysis was undertaken to verify the seismic performance of the connecting pavilions that step down the site and minimise materials

usage. Detailed investigation of the fuel tanks' existing material properties and structural performance allowed the sustainable regeneration and repurposing of the southern tank as a vast subterranean art space while supporting the new building above with limited structural interventions.

Close collaboration was essential to successfully delivering a building with such intricate geometry – the curved roofs, the multiple column transfers required for the pavilions and a series of curved and spiral staircases. A highlight is the 1100-square-metre column-free gallery enclosed by a trafficable landscaped roof supported by an array of closely spaced 37-metre-long steel portal frames.

Making the complex appear simple was a key consideration for the design and engineering teams. The refined structural design makes a significant contribution to the building's architectural aesthetic. As part of SANAA's vision, the gallery roof steelwork is exposed, which presented additional engineering challenges to achieve a seamless integration of structure and reticulated services with clean and subtle connections. 'SANAA's buildings seem so delicate, the challenge we have is making sure the structure can support the building but still looks elegant', said Arup project manager Andrew Phillips.[2]

Above: Detail of SANAA's 1:1 scale model study of the entry level ceiling and facade Right: The curved roof on lower level 1 looking towards the restaurant Opposite: Naala Badu and surrounding campus under construction, February 2022

Appendices

Elevation from Art Gallery Road

Site plan

Scale: 1:4000

Entry level

1 Gallery 1
2 Entry Plaza
3 Entry Pavilion
4 Shop
5 Terrace

Scale: 1:1000

Lower level 1

1 Gallery 2
2 Kitchen
3 Cafe
4 Terrace
5 Education studio

Scale: 1:800

Lower level 2

1 Gallery 3
2 Media Lab
3 Gallery 7
4 Gallery 5
5 Gallery 4
6 Multipurpose space
7 Art commission

Scale: 1:1000

Lower level 4

1 Gallery 8 (The Tank)
2 Back of house

Scale: 1:1000

Section views – full site

1 Entry Plaza
2 Entry Pavilion
3 Terrace
4 Gallery 2
5 Gallery 5
6 Gallery 4
7 Back of house
8 Cafe
9 Cafe terrace
10 Atrium
11 Gallery 3
12 Gallery 8 (The Tank)

Scale: 1:800

Section view detail

Scale: 1:100

Pigmented concrete

Green roof

Gutter

Galvanised fascia beam

Polished concrete

Steel column

Glazing

FOYER

Aluminium louvers

Stone cladding

GALLERY

Rammed earth wall

Polished concrete finish

EXPRESS WAY

Acoustic plaster

STUDIO

FOYER

Glazing

GARDEN

Rammed earth
Steel column
Polished concrete

Landscape

Pigmented concrete

Concrete planter

Existing slab

Existing wall

Existing columns

Existing oil tank retaining wall

Rock

OIL TANK GALLERY

Polished concrete finish

Section view detail – cafe roof

Green roof (t=varies 50mm min.)
Drainage cell (t=70mm)
Waterproofing
Insulation (t=70mm)
Composite decking (t=175mm)
Steel structure – galvanized + painted (d=309mm)

953 93

Grate
Gutter

Fascia beam
Hot dipped galvanized steel

435

296

Extruded aluminum glazing channel
Clear natural anodized

Perforated aluminum ceiling (t=2mm)
Fire rated zone

Glazing
Low E HS t=8/A t=12/Lam HS t=5+5

Glazed mullion
Low iron annealed t=15+15+15

Section view detail – typical gallery

Planter with drainage cell (t=85-170mm)
Pigmented concrete (t=80mm)
Waterproofing
Insulation (t=varies)
Concrete decking (t=175mm)
Steel structure (d=310mm)

Grate
Gutter

965 125

Pigmented concrete
Topping (t=100mm)

85
100
160
100

607

213

Aluminum ceiling louvers (t=4mm)

Limestone cladding
(h=50, t=50, l=800-1500mm)
Stainless steel shelf bracket
Fiber cement board (t=9mm)
Top hat batten @ 800mm CL
Vapor permeable membrane
Stainless steel sheeting
Steel stud (d=150mm)
Insulation (t=150mm)

Project specifications and credits

Building specifications	Construction:	2019–22
	Site area:	23,045 sqm
	Building area:	11,686 sqm
	Total floor area:	17,595 sqm
	Levels:	Five
	Sustainability:	6 Star Green Star Design & As Built rating
Design and construction team	Architect:	Kazuyo Sejima + Ryue Nishizawa / SANAA, Tokyo
	Executive architect:	Architectus, Sydney
	Landscape architects:	McGregor Coxall, Sydney GGN, Seattle Kathryn Gustafson, Seattle and Paris
	Builder:	Richard Crookes Constructions, Sydney
	Structural engineer:	Arup, Sydney
	Civil engineer:	Arup, Sydney
	Hydraulic & fire engineer:	Arup, Sydney
	Acoustic engineer:	Arup, Sydney
	Mechanical engineer:	Steensen Varming, Sydney
	Facade engineer:	Surface Design, Sydney
	Building certification and accessibility:	Group DLA, Sydney
	Delivery authority:	Infrastructure NSW, Sydney
Project funding	Total project cost:	AU$344 million
	NSW Government funding:	AU$244 million
	Private donor contributions:	AU$100 million

Key project milestones

2008 — A masterplan for the expansion of the Art Gallery is commissioned by the Board of Trustees.

2011 — The masterplan, jointly prepared by the Art Gallery and Johnson Pilton Walker, is completed.

2012 — **June:** Michael Brand commences as director of the Art Gallery.

2013 — **March:** Launch of the Sydney Modern strategic vision to transform the Art Gallery into an art museum for the 21st century.

June: The NSW Government commits $10.8 million to advance planning for the Art Gallery expansion.

2014 — **February:** Announcement of the Sydney Modern Project international design competition.

September: The jury is announced for the design competition.

October: Twelve shortlisted architects are announced for Stage 1 submissions.

2015 — **January:** Five shortlisted architects are announced for Stage 2 submissions.

May: SANAA is announced as preferred architect.

June: The NSW Government commits $4 million to progress design and planning.

September: The first of a series of design workshops is held at SANAA's Tokyo studio.

2016 — A key design change is made: to remove most of the structure from the land bridge, including the internal link between the two buildings.

2017 — **June:** The NSW Government commits $244 million to build the Sydney Modern Project. The Art Gallery announces the Sydney Modern Project capital campaign, with $70 million already pledged towards its $100 million fundraising target. The lead gift of $20 million was made by the Susan and Isaac Wakil Foundation.

September: The SANAA team makes its first visit to the former Second World War oil tank, which will be preserved in their design for the new building.

November: A State Significant Development Application is lodged with the NSW Department of Planning and Environment and exhibited to the public.

2018 — **April:** A Response to Submissions Report is lodged with the NSW Department of Planning and Environment, following the review and consideration of submissions.

October: Infrastructure NSW, on behalf of the NSW Government and the Art Gallery, issues a formal Request for Tender for construction of the building.

November: The State Significant Development Application is approved by the NSW Minister for Planning. The Art Gallery announces that it has exceeded its $100 million fundraising target to support construction of the new building, creating the largest government and philanthropic arts partnership of its kind in Australia to date.

December: Land tenure deeds for the site are signed by the Art Gallery, Roads and Maritime Services, and the Royal Botanic Gardens and Domain Trust.

2019 — **September:** The NSW Government announces Richard Crookes Constructions as the selected contractor for the Sydney Modern Project.

November: The Art Gallery hosts a groundbreaking ceremony to mark the start of construction.

2020 — **March:** For ten weeks, the Art Gallery shuts its doors to the public due to the global COVID-19 pandemic. Construction continues on the new building.

2021 — The Art Gallery celebrates its 150th anniversary.

June: The Art Gallery is once again required to close to the public due to the pandemic, this time for fifteen weeks.

July: Construction is paused for eleven days as the NSW Government closes construction sites in Greater Sydney to minimise transmission of COVID-19.

November: The highest structural point of the new building is reached; a 'topping out' ceremony is held.

2022 — **April:** The NSW Government announces the opening date of the new building: 3 December 2022.

July: Kazuyo Sejima and Ryue Nishizawa make their first visit to the site since November 2019, having been unable to travel due to the pandemic.

September: The NSW Government announces the completion of the building's major construction phase.

24 November: A smoking ceremony is held to welcome Art Gallery staff to the new building.

25 November: School children from across NSW are the first visitors in the new building as the preview week commences.

3 December: The expanded and transformed Art Gallery opens to the public.

2023 — **June:** The building wins the prestigious Sulman Medal for Public Architecture awarded by the Australian Institute of Architects (NSW Chapter)

November: The building wins a National Award for Public Architecture from the Australian Institute of Architects, and the 2023 *Apollo* Award for Museum Opening of the Year, in London.

Notes

Foreword

1 Maurice Merleau-Ponty, *Phenomenology of perception*, The Humanities Press, Routledge, New Jersey, 1962.

Michael Brand: A future to dream into

1 The history of the 153-year-old Art Gallery of New South Wales is told in Steven Miller, *The Exhibitionists*, Art Gallery of New South Wales, Sydney, 2021. I have also written elsewhere about how we created an art museum campus on Gadigal Country overlooking Sydney Harbour. See Michael Brand (ed), 'Introduction' and Chapter 1, *The Sydney Modern Project: transforming the Art Gallery of New South Wales*, AGNSW, Sydney, 2022.

2 The masterplan by Sydney architecture firm Johnson Pilton Walker, under the leadership of Richard Johnson and Graeme Dix, was submitted to a Strategy and Development Subcommittee comprising trustees Guido Belgiorno-Nettis (chair), Steven Lowy and David Baffsky, director Edmund Capon, and deputy director Anne Flanagan supported by Trish Kernahan, then manager of administration and strategy.

3 Art Gallery of New South Wales and Johnson Pilton Walker, 'Executive summary', *Sydney Modern masterplan framework*, 6 Sep 2012, Sydney, p 3, majorprojects. planningportal.nsw.gov.au/ prweb/PRRestService/mp/01/ getContent?AttachRef=SSD-6471%212019022 7T065330. 587%20GMT, accessed 17 Mar 2023.

4 These projects involved working with London-based architect Rick Mather and Philadelphia-based landscape architects Olin Partnership at the Virginia Museum of Fine Arts in Richmond, Boston-based architects Machado and Silvetti at the Getty Villa in Los Angeles, and Tokyo-based architect Fumihiko Maki with Beirut-based landscape architect Vladimir Djurovic at the Aga Khan Museum in Toronto. Earlier, I had been co-director of the Smithsonian Institution's Mughal garden project in Pakistan.

5 The NSW Government media release announced funding of $10.8 million in June 2013. The brief was developed with my colleagues Anne Flanagan (then deputy director), Suhanya Raffel (then director of collections, and deputy director after Flanagan's retirement in 2015) and Sally Webster (who would soon be appointed head of the Sydney Modern Project) along with architect Graeme Dix from Johnson Pilton Walker, who knew the existing building from his work on our 2003 addition and on the masterplan. John Gale was brought on as project director. Architect Richard Johnson, also from Johnson Pilton Walker, who held deep knowledge of the existing building as architect of the Asian Lantern galleries, was appointed competition adviser.

6 The jury members were: Kathryn Gustafson, landscape architect with Gustafson Guthrie Nichol (Seattle) and Gustafson Porter (London); Michael Lynch, then CEO of the West Kowloon Cultural District Authority in Hong Kong and former CEO of the Sydney Opera House; Toshiko Mori, Robert P Hubbard Professor in the Practice of Architecture, Harvard University Graduate School of Design; Glenn Murcutt, Sydney-based architect and recipient of the Pritzker Architecture Prize in 2002; Juhani Pallasmaa, Helsinki-based architect, academic and widely published writer; and Hetti Perkins, Sydney-based member of the Eastern Arrernte and Kalkadoon Aboriginal communities and a filmmaker, author and former senior curator of Aboriginal and Torres Islander art at the Art Gallery.

7 The members of the Architects Advisory Panel were Paul Berkemeier (chair), then national president of the Australian Institute of Architects; Peter Poulet, then NSW government architect; Graham Jahn, director, City Planning, Development and Transport, City of Sydney; Eleonora Triguboff, then a trustee at the Art Gallery; and Anne Flanagan, then deputy director at the Art Gallery.

8 The twelve firms were: Candelapas Architects (Sydney), David Chipperfield Architects (London and Milan), Fender Katsalidis (Melbourne), Herzog & de Meuron (Basel), Kengo Kuma (Tokyo), Kerry Hill (Singapore and Fremantle), Nieto Sobejano Arquitectos (Madrid), Rahul Mehrotra (Boston and Mumbai), Renzo Piano Building Workshop (Genoa), SANAA (Tokyo), Sean Godsell Architects (Melbourne), Tod Williams Billie Tsien Architects (New York).

9 Since the 21st Century Museum of Contemporary Art opened in Kanazawa in 2004, SANAA had successfully designed the Glass Pavilion at the Toledo Museum of Art (2006), the New Museum of Contemporary Art in New York (2007), the Rolex Learning Center at the Ecole Polytechnique Fédérale in Lausanne (2010) and the Louvre-Lens Museum (2012). Grace Farms in Connecticut was nearing completion at the time of the announcement and opened in October 2015. In 1997, SANAA won the competition to expand the Museum of Contemporary Art in Sydney, but this project did not progress any further.

10 SANAA architectural statement, AGNSW media kit, April 2021.

11 Sydney Modern Project, *Competition jury selection report*, 2015, www.datocms-assets. com/42890/1643597391-sydney-modern-project-competition-jury-selection-report.pdf, accessed 4 May 2023.

12 The core Art Gallery team was Michael Brand, Suhanya Raffel (until 2016), Maud Page (from 2017), Sally Webster and Nicholas Wolff, along with Luke Johnson from SANAA's Sydney-based executive architects, Architectus. The core SANAA team was Kazuyo Sejima, Ryue Nishizawa, Yumiko Yamada, Asano Yagi, Ichio Matsuzawa and Hyunsoo Kim.

13 Between 2013 and 2015, the German sculptor and photographer Thomas Demand spent many hours at SANAA's studio observing their working processes and photographing details of their architectural models for a body of work that was subsequently displayed in his *Latent Forms* exhibition at Sprüth Magers in London, 13 October – 19 December 2015. See spruethmagers.com/ exhibitions/thomas-demand-latent-forms-london, accessed 31 July 2023.

14 David Gonski had previously served as board president from 1997 to 2006. His successor, Steven Lowy, had been board president when we launched the Sydney Modern Vision in 2013. He was followed by Guido Belgiorno-Nettis, who served in the role from 2014 to 2015.

15 A Capital Campaign Committee (chaired by then board vice president Mark Nelson; see list of members on p 214) had been launched in May 2015 and $70 million had already been raised by the time of this announcement.

16 The northern tank was converted to back-of-house space, including a new loading dock to support Art Gallery operations.

17 Kazuyo Sejima, 'Current trials and errors', *GA Architect: SANAA: Kazuyo Sejima, Ryue Nishizawa, 2011–2018*, Ada Editors, Tokyo, 2018, p 14.

18 Ryue Nishizawa, 'Architecture of environment', *GA Architect*, 2018, p 11.

19 For a detailed discussion of this process, see Michael Brand (ed), *The Sydney Modern Project: transforming the Art Gallery of New South Wales*, AGNSW, Sydney, 2022.

20 A significant staffing change took place in the middle of developing the curatorial narrative, when deputy director and director collections Suhanya Raffel left the Art Gallery to become director of M+ in Hong Kong and was replaced in February 2017, by Maud Page.

21 The building site was also shut down for a day in December 2019 due to smoke from the bushfires that had ravaged the Sydney region.

22 The Project Control Group (see list of members on p 214) was chaired by John Morschel, working closely with Infrastructure NSW's project director Andrej Stevanovic and the Art Gallery's head of project Sally Webster. The Project Working Group was chaired by Sally Webster and included the Art Gallery's Executive Team: director Michael Brand, deputy director and director of collections Maud Page, chief operating officer Hakan Harman, director of development John Richardson and director of public engagement Miranda Carroll, as well as project director Andrej Stevanovic, the Art Gallery's head of facilities Paul Collis and SMP assistant project manager Bianca Tomanovic.

23 Lee Mingwei, quoted in 'Essential questions: Lee Mingwei', *Look*, Oct–Nov 2022, pp 18–19. *Spirit House* was inspired by Lee's experience of visiting the Art Gallery of New South Wales during his first visit to Australia in 1999. At the Art Gallery he encountered a Sui dynasty (581–618 CE) Chinese Buddhist sculpture and felt drawn to it. Lee was at a crossroads in his life and asked the Buddha to guide him on his journey. His wish fulfilled, he returned some years later and revisited the figure to express his gratitude, as well as the hope its spirit would guide another.

24 The Art Gallery jumped from number 52 to 28 in the top 100 list of the *Art Newspaper*'s 2023 visitor survey, with visitation up 51% from 2019. Lee Cheshire and José da Silva, *The Art Newspaper* '100 most popular art museums in the world—blockbusters, bots and bounce-backs', 27 March 2024, theartnewspaper. com/2024/03/26/the-100-most-popular-art-museums-in-the-world-2023, accessed 27 March 2024.

25 The 2024 iteration of *Volume* included André 3000 and Kim Gordon as headliners. The Tank space is also being used for a series of major commissions, including Adrián Villar Rojas *The End of Imagination* in 2022 and Angelica Mesiti *The Rites of When* in 2024.

26 The Sir John Sulman Medal for Public Architecture was awarded to design architects SANAA and executive architects Architectus by the NSW chapter of the Australian Institute of Architects. Tonkin Zulaikha Greer (TZG) also won an Award for Public Architecture for the Art Gallery's new research library and Members Lounge in Naala Nura, and Akin Atelier won an Award for Interior Architecture for the new Gallery Shop in Naala Badu. In November 2023, international art magazine *Apollo* awarded the Art Gallery's new building Museum Opening of the Year.

27 Sebastian Smee, 'Sydney finally gets the destination museum it deserves', *The Washington Post*, 14 March 2023, washingtonpost.com/arts-entertainment/2023/03/14/sydney-modern-museum-opera-house, accessed 14 March 2023.

Eve Blau: Staging the unpredictable

1 Kazuyo Sejima, quoted in *The encounters in the 21st century: polyphony – emerging resonances*, 21st Century Museum of Contemporary Art & Tankosha Publishing Co, Kanazawa, 2005, p 151.

2 Kazuyo Sejima, quoted in Alejandro Zaera, 'A conversation with Kazuyo Sejima and Ryue Nishizawa', *El Croquis*, no 99, 2000 (Kazuyo Sejima, Ryue Nishizawa: 1995–2000), p 16.

3 Kazuyo Sejima quoted in *El Croquis 77[1]+99+121/122: Sejima Nishizawa SANAA 1983–2004*, El Croquis, Madrid, 2007, p 23.

4 Ryue Nishizawa, quoted in Hans Ulrich Obrist, *Lives of the artists, lives of the architects*, Allen Lane, London, 2015, p 451.

5 John Cage, *Silence: lectures and writings*, Wesleyan University Press, Hanover, 1973, p 13.

6 Manfredo Tafuri, *Theories and history of architecture*, trans Giorgio Verrecchia, Harper & Row, New York, 1976, pp 104–05.

7 Ryue Nishizawa, quoted in Agustín Pérez Rubio (ed), *Houses: Kazuyo Sejima + Ryue Nishizawa SANAA*, Actar, Barcelona, 2007, p 15.

8 Sejima, in *El Croquis 77[1]+99+121/122*, p 19.

9 Tafuri 1976, p 105.

10 Yuko Hasegawa, quoted in Meruro Washida (ed), *Kazuyo Sejima + Ryue Nishizawa / SANAA*, 21st Century Museum of Contemporary Art, Kanazawa, 2005, pp 100–01.

11 Sejima here is referencing photographs by Hisao Suzuki of models in the studio. Kazuyo Sejima, 'Talking about study models', in Luis Fernandez-Galiano (ed), *SANAA: Sejima & Nishizawa 1990–2017*, Arqitectura Viva, Madrid, 2017, p 19.

12 Sejima's project is one component of an ambitious program initiated and sponsored by Soichiro Fukutake, the art collector and chairman of the Benesse Corporation, to develop islands in the Seto Inland Sea (Naoshima, Inujima and Teshima, in particular) into an international centre for contemporary art and architecture, while promoting the existing island culture, restoring the built and natural landscapes on the islands, and merging the art and architecture with them.

13 Kazuyo Sejima, 'Inujima Art Project (Second Stage, Phase 1)', Tokyo, July 2010. Internal document by SANAA regarding the Inujima Art Project.

14 Maki Onishi, 'Architecture and environment as one: a conversation with Kazuyo Sejima and Ryue Nishizawa', *El Croquis*, no 205, 2020 SANAA [I] 2015–20), p 15.

15 Sejima, quoted in *El Croquis*, no 205, 2020, p 17.

16 Michael Brand (ed), 'Introduction: transforming the Art Gallery of New South Wales', *The Sydney Modern Project: transforming the Art Gallery of New South Wales*, AGNSW, Sydney, 2022, pp 17–35; Maud Page, 'Hope, wonder and audacity', *Look* (AGNSW members magazine), Dec 2022 – Jan 2023, pp 12–13.

17 Sejima, quoted in Onishi 2020, p 13.

Anthony Burke: Trusting architecture by looking between

1 Alexander Dorner, 'Why have art museums?', 1941, in Sarah Ganz Blythe and Andrew Martinez (eds), *Why art museums?: the unfinished work of Alexander Dorner*, MIT Press, Cambridge, MA, 2018, p 183. After moving to Providence to direct the Rhode Island School of Design Museum in 1938, Alexander Dorner, perhaps most notably, asked the question 'What does an art gallery do?' back in 1941. At that time, wrestling with the transition from neoclassical to more modern sensibilities in curation, Dorner was interested in the physical impact of that movement on the nature of the art museum itself.

2 Dorner 1941, p 244.

3 Dorner 1941, p 244.

4 'This need raises a multitude of problems, such as how to establish a balance between ephemeral, highly perishable, immediate expressions, and forms which will have sufficient duration to become strong and valid, or how to educate a generation with potentialities for multiple and diversified aesthetic responses without at the same time having these diversifications cancel each other out or merely produce confusion', Margaret Mead, 'Art and reality: from the standpoint of cultural anthropology', *College Art Journal*, vol 2, no 4, part 1, May 1943, pp 119–21, jstor.org/stable/773343.

5 Sejima's curatorial agenda for the 12th Architectural Biennale in Venice was 'People meet in architecture'.

6 *Ryue Nishizawa / SANAA: Grace Farms*, no 13 in the series *Source books in architecture*, ed Benjamin Wilke, Applied Research + Design Publishing, an imprint of Oro Editions, Novato, CA, 2019, p 23.

7 Brit Andresen and Peter O'Gorman, 'Intentions in architecture', *Ume 22, The International Architecture Magazine*, 2011, p 11, umemagazine.com.

8 Maki Onishi, 'Architecture and environment as one: A conversation with Kazuyo Sejima and Ryue Nishizawa', in *El Croquis*, no 205, 2020 (SANAA [I] 2015–20), p 9.

9 From the exhibition *MA: Space-Time in Japan*, curated by Arata Izozaki, 1978, Musée des Arts Décoratifs, Paris.

10 Many authors, Japanese and Western, have written about this quality of Japanese architecture and culture. For a relatively recent and broad outline, see Günter Nitschke, 'MA: place, space, void', 16 May 2018, in *Kyoto Journal*, no 98, digital issue, kyotojournal.org/culture-arts/ma-place-space-void, accessed 13 Mar 2023.

11 Juliana Engberg, 'Beyond the white cube', in Natasha Hoare, et al (eds), *The new curator*, Laurence King Publishing, London, 2016, p 8.

12 Onishi 2020, p 293.

13 Yuko Hasegawa, 'An architecture of awareness for the twenty-first century' in Yuko Hasegawa, *Kazuyo Sejima + Ryue Nishizawa: SANAA*, Electra Architecture Mondadori, Milan, 2006, p 7.

14 Blythe, 'The way beyond museums', in Blythe and Martinez 2018, p 115.

Yuko Hasegawa: A museum that fosters an ecological perspective

1 'Intra-action' is a term that refers to the ontological dimension of the mutual configuration of entangled agencies, rather than a mode of interaction premised on individual, independently pre-existing elements. The dynamic, topological reconstruction of the world also reflects this entanglement. See Karen Barad interview with Adam Kleinman, 'Inter-actions', *mousse*, no 34, summer 2021, pp 76–81.

2 SANAA's urban planning project for Oslo sought to boost the number of households by 100,000 within ten years. It proposed to increase the floor area occupied by housing by placing buildings of approximately the same scale close to existing structures, thereby maintaining a decentralised and traditional landscape as far as possible. The site of the former coal mine occupied by the Louvre-Lens Museum in Lens, France, is a UNESCO World Heritage Site, and the layout and size of the buildings were decided so as not to disturb the landscape of this former coal mine site. The ground of the site rises 4 meters from the surrounding area to form a hill, so the buildings were arranged according to this topography. A square building with glass walls was placed in the centre, with four rectangular boxes on each side of it.

3 Yuko Hasegawa, 'Flexibility of architecture', *21st Century Museum of Contemporary Art*, exh cat, 21st Century Museum of Contemporary Art, Kanazawa, 2004, pp 102.

4 Internal document by SANAA regarding the Sydney Modern Project.

Sally Webster: Building the dream

1 SANAA, competition entry, 2015, artgallery.nsw.gov.au/sydney-modern-project/about-the-project/architecture-and-design/design-competition/#stage-two-shortlisted-architects.

2 Modified NSW Government GC21 Construction Contract, executed between Richard Crookes Constructions and Infrastructure NSW. Under the contract, executive architect Architectus was novated to Richard Crookes Constructions.

3 Andrej Stevanovic was engaged by Infrastructure NSW as project director and Asano Yagi was SANAA's senior designer and project manager. I had been working on the Sydney Modern Project since 2013, and served as head of the project from 2015. During construction I took on the role of client representative working with Daniel Griffin and Bianca Tomanovic as part of the Art Gallery's delivery team. See full list of project teams on pp 214–15.

4 See Maud Page, 'The commissioning pulse', in Michael Brand (ed), *The Sydney Modern Project: transforming the Art Gallery of New South Wales*, Art Gallery of NSW, Sydney, 2022.

5 SANAA, architectural statement, Art Gallery of NSW press preview opening media kit, 29 November 2022.

6 In March 2021 the *Ever Given* ran aground in the Suez Canal, blocking it for six days.

7 SANAA, email to Anthony Salerno, Sally Webster and Denise Knight, 22 February 2023.

8 Description sourced from a transcript of a video interview filmed on site with John Oliver from Rammed Earth Constructions in July 2022, held by the Art Gallery of New South Wales.

9 On 17 July 2021 the NSW Government announced tighter COVID-19 restrictions for the Greater Sydney Metropolitan area, including the closure of construction sites from 19 to 30 July 2021, to minimise community transmission.

10 Between January and July 2022, Sydney registered 123 days of rain against the average of 88 days.

11 See Michael Brand (ed), *The Sydney Modern Project: transforming the Art Gallery of New South Wales*, Art Gallery of NSW, Sydney, 2022.

Architecture in focus

Adaptive reuse

1 Adrián Villar Rojas, in 'Adrián Villar Rojas on his commission for The Tank', media release on the Sydney Modern Project, Art Gallery of New South Wales, 21 September 2022.

Lee Mingwei's *Spirit House*

1 For this and other references to Melanie Eastburn, see her 'Asian art at AGNSW: Sydney Modern and the Asian galleries', *TAASA Review*, vol 31, no 4, Dec 2022, taasa.org.au/taasa-review/?FeviewUUID=4ee994fc-f836-409c-a813-73f13482069b, accessed 29 Jun 2023.

2 Lauren Sams, 'Will Sydney's new modern art gallery be worth its $340m price tag? *Australian Financial Review Magazine*, 27 Jul 2022, afr.com/life-and-luxury/design/will-sydney-s-new-modern-art-gallery-be-worth-its-340m-price-tag-20220609-p5asic, accessed 29 June 2023.

Rammed earth walls

1 Kazuo Sejima, quoted in 'Art Gallery of NSW / Sydney Modern Project by SANAA', *Idreit*, 16 Jan 2023, idreit.com/article/art-gallery-of-nsw-sydney-modern-project-by-sanaa, accessed 30 Jun 2023.

2 From a transcript of a video interview with John Oliver from Rammed Earth Constructions in July 2022, held by the Art Gallery of New South Wales.

Sustainability

1 Green Building Council of Australia, media release, 21 Nov 2018, new.gbca.org.au/news/gbca-media-releases/art-gallery-new-south-wales-first-public-art-museum-achieve-6-star-green-star-design-rating, accessed 4 July 2023.

Engineering

1 Andrew Johnson, quoted in 'Sydney Modern Project team: Arup', Art Gallery of NSW press preview opening media kit, 29 November 2022.

2 Andrew Philips, quoted in Julie Power, How to build a "light as a feather" gallery above eight lanes of traffic, *Sydney Morning Herald*, 1 Dec 2022, smh.com.au/national/nsw/how-to-build-a-light-as-a-feather-gallery-above-eight-lanes-of-traffic-20221130-p5c2dc.html, accessed 22 Aug 2023.

Selected reading

Art Gallery of New South Wales. *Competition jury selection report: Sydney Modern Project*, 2015, www.datocms-assets.com/42890/1643597391-sydney-modern-project-competition-jury-selection-report.pdf

Art Gallery of New South Wales & Johnson Pilton Walker. 'Executive summary', *Sydney Modern masterplan framework*, 6 Sep 2012, Sydney, majorprojects.planningportal.nsw.gov.au/prweb/PRRestService/mp/01/getContent?AttachRef=SSD-6471%2120190227T065330.587%20GMT

Blau, Eve. 'Inventing new hierarchies', The Pritzker Architecture Prize essay on Kazuyo Sejima and Ryue Nishizawa, 2010 laureates, The Hyatt Foundation / The Pritzker Architecture Prize, Chicago, 2011, pritzkerprize.com/2010/essay

Blythe, Sarah Ganz & Andrew Martinez (eds). *Why art museums?: the unfinished work of Alexander Dorner*, MIT Press, Cambridge, MA, 2018

Brand, Michael (ed). *The Sydney Modern Project: transforming the Art Gallery of New South Wales*, Art Gallery of New South Wales, Sydney, 2022

Cheshire, Lee. '"This land has an important history": Pritzker Prize-winning architects SANAA on their design for the Art Gallery of New South Wales', *Art Newspaper*, 29 Nov 2022, theartnewspaper.com/2022/11/28/this-land-has-an-important-history-pritzker-prize-winning-architects-sanaa-on-their-design-for-the-art-gallery-of-new-south-wales

El Croquis. 'SANAA [II] Kazuyo Sejima and Ryue Nishizawa 2015–23', *El Croquis*, 220/221, June 2023

Fukui, Masako (host). 'The Sydney Modern Project', podcast, *In the studio*, BBC World News, 14 Feb 2023, bbc.co.uk/programmes/p0f2ykwx

Hasegawa, Yuko. *Kazuyo Sejima + Ryue Nishizawa: SANAA*, Phaidon Press, New York, 2012

Kazuyo Sejima & Ryue Nishizawa (eds). *Kazuyo Sejima Ryue Nishizawa SANAA*, vol 1: 1987–2005, vol 2: 2005–15, vol 3: 2014–21, TOTO Publishing, Tokyo, 2022

Miller, Steven. *The Exhibitionists: a history of Sydney's Art Gallery of New South Wales*, Art Gallery of New South Wales, Sydney, 2021

Neustein, David. 'Modern times', *Monthly*, 28 Jan 2023

Power, Julie. 'Escher in a new era as gallery thinks outside boxes', *Sydney Morning Herald*, 26 Nov 2022

Rixson, Andrew. 'Sydney Modern broadens the reach of the Art Gallery of New South Wales', *RIBA Journal*, 21 Feb 2023, ribaj.com/buildings/sanaa-sydney-modern-art-gallery-new-south-wales-australia-museum-extension

Smee, Sebastian. 'Sydney finally gets the destination museum it deserves', *Washington Post*, 14 Mar 2023, washingtonpost.com/arts-entertainment/2023/03/14/sydney-modern-museum-opera-house

Wilke, Benjamin (ed), Ryue Nishizawa (narrator). *Ryue Nishizawa / SANAA: Grace Farms*, no 13 in the series *Source books in architecture*, Applied Research + Design Publishing, an imprint of Oro Editions, Novato, CA, 2019

Wilson, Fiona. 'Double vision: Tokyo', *Monocle*, no 158, Nov 2022

Worrall, Julian. 'Move over Sydney Opera House – there's a new superstar in town', *Guardian*, 29 Nov 2022

Young, Sarah. 'Sydney Modern Project', *Whitewall*, issue 64, winter 2022

Acknowledgements

Michael Brand
Director
Art Gallery of New South Wales, Sydney

As we celebrate the second anniversary of the opening of the expanded Art Gallery of New South Wales and its new building designed by Pritzker Prize–winning architects Kazuyo Sejima and Ryue Nishizawa of SANAA, we acknowledge the team that has delivered a transformative space in which visitors to our state art museum can experience art in new and exciting ways here in Sydney, on Gadigal Country overlooking Sydney Harbour.

The Art Gallery is delighted that the Sydney Modern Project provided SANAA the opportunity to build its first project in Australia, and we thank the founders and their team for their contribution and collaboration in designing such a magnificent work of architecture. Photographing SANAA's architecture for these pages is the exceptionally talented Iwan Baan. Viewing architecture through his lens is a joy and offers fresh perspectives on our experiences of the building.

We also thank the project's executive architect Architectus for its work as part of a global team that realised this ambitious vision. And for building our new museum facility – notwithstanding the challenges of a pandemic and torrential rains – I thank Richard Crookes Constructions and Infrastructure NSW.

I thank my esteemed colleagues on the Sydney Modern Project international design competition jury, including Juhani Pallasmaa, whose considered foreword proposes our expansion as exemplifying a new concept of the museum. I am deeply grateful to Eve Blau, Anthony Burke and Yuko Hasegawa for sharing their expertise through their essays. I also thank my colleague Sally Webster, head of the Sydney Modern Project and now the Art Gallery's director of program delivery, for her essay, which shines a light on the complexities of delivering and constructing cultural development projects – in our case the most significant to open in Sydney since the Opera House half a century ago.

This book completes a suite of publications about the transformation and expansion of the Art Gallery, the first being *The Exhibitionists: a history of Sydney's Art Gallery of New South Wales*, on the occasion of our 150th anniversary in 2021, and the second, *The Sydney Modern Project: transforming the Art Gallery of New South Wales*, on the occasion of the completion of the project in 2022.

Once again, this book – much like the Sydney Modern Project itself – would not have been possible without expert input from the remarkable Art Gallery community, many members of which are listed in the following pages. I am deeply grateful to the Art Gallery's brilliant Executive Team, currently deputy director and director of collections Maud Page, chief operating officer Hakan Harman, director of audiences and development John Richardson, and Sally Webster, as mentioned, and former colleagues Miranda Carroll, John Wicks, Jacquie Riddell, Suhanya Raffel and Anne Flanagan. I also acknowledge the contributions of Art Gallery staff; members of the Board of Trustees, especially president David Gonski and his immediate predecessors Guido Belgiorno-Nettis and Steven Lowy; chairs of the Project Control Group, John Morschel and Andrew Roberts; project directors Andrej Stevanovic, Nicholas Wolff and John Gale; and our project governance committees who expertly guided the project from vision to completion.

The Art Gallery is sincerely grateful to the NSW Government for supporting the notion of a public art museum by providing such significant funding for our expansion. I am filled with gratitude for the many generous benefactors, inspired by lead donors Isaac and Susan Wakil and capital campaign chair Mark Nelson, who have made our transformation possible as part of the largest government and philanthropic arts partnership in Australia to date.

Throughout the writing and editing process we have all relied upon the expert guidance of managing editor Faith Chisholm and editor Linda Michael and the feedback of our readers. And for his design of the book, Dominic Hofstede, partner at the international design studio Mucho. Thank you all.

I also thank my chief of staff Michelle Raaff, and Sydney Modern Project communications manager Denise Knight for their contributions to this book.

Finally, as always, I salute the exceptional and inspiring work of all the artists we have the honour to work with, and whose creativity we have the pleasure of sharing with our audiences in our expanded public art museum. On a personal level, I could not have achieved any of this without the support and love of my wife, Tina Gomes Brand.

Governance and delivery teams 2013–22

COMPETITION BRIEF DEVELOPMENT
2013

Michael Brand
Sandra Di Bella
Graeme Dix
Anne Flanagan
John Gale
Richard Johnson AO
Matt Nix
Suhanya Raffel
Sally Webster

DESIGN COMPETITION
2014–15

Architects advisory panel
Paul Berkemeier, chair
Anne Flanagan
Graham Jahn AM
Peter Poulet
Eleonora Triguboff

Competition adviser
Richard Johnson AO

Competition jury
Michael Brand, chair
Kathryn Gustafson
Michael Lynch AM
Toshiko Mori
Glenn Murcutt AO
Juhani Pallasmaa
Hetti Perkins

Observer
Guido Belgiorno-Nettis AM

Jury secretariat
Anne Flanagan
Penny Sanderson
Sally Webster

Technical advisory panel
Graeme Dix, chair
Chris Arkins
Sandra Di Bella
Chris Bylett
John Gale
Richard Green
Michael Harrold

Clare Swan
Peter Watts AM

Probity adviser
Andrew Marsden

SYDNEY MODERN PROJECT JOINT STEERING COMMITTEE
2015–17

Guido Belgiorno-Nettis AM, chair (2015)
David Gonski AC, chair (2016–17)
Jim Betts
Michael Brand
Andrew Cappie-Wood AO
Erin Flaherty
Anne Flanagan
John Morschel
Mark Nelson
Andrew Roberts
Eleonora Triguboff
Sally Webster
John Wicks
David Withey
Nicholas Wolff

PROJECT STEERING COMMITTEE
2017–22

David Gonski AC, chair
Tarek Barakat (2018–19)
Jim Betts (2017–19)
Michael Brand
Amy Brown (2018–19)
Matt Conrow (2022)
Simon Draper PSM (2019–22)
Scott Ellis (2019–20)
Anne Flanagan
Kate Foy (2019–22)
Sonya Jenkins (2020)
Craig Limkin (2017–19)
Roslyn Mayled (2018–22)
Sinead McLaughlin (2020–22)
Samantha Meers AO (2017–19)
John Morschel
Mark Nelson
Alex O'Mara (2017–19)
Eammon Oxford (2021)
Annette Pitman (2019–22)
David Riches PSM (2018–19)
Andrew Roberts (2017–19)

Benjamin Rooke (2019)
Cathy Thurley (2018)
Lucy Turnbull AO (2019–21)
Sally Walkom (2019)
Cassandra Wilkinson OAM (2017–19)

Observers
Tom Gellibrand (2019–22)
Hakan Harman (2018–22)
Maud Page
Andrej Stevanovic (2018–22)
Sally Webster
John Wicks (2017–18)
Nicholas Wolff (2017–19)

Secretariat
Bianca Tomanovic

PROJECT CONTROL GROUP
2017–22

Andrew Roberts, chair (2017–19)
John Morschel, chair (2019–22)
David Antaw (2018)
Michael Brand
Scott Ellis (2019)
Anne Flanagan
Tom Gellibrand (2019–22)
Hakan Harman (2018–22)
Sally Herman (2019–22)
Craig Limkin (2017–19)
Roslyn Mayled (2018–22)
Maud Page (2018–22)
Annette Pitman (2019–22)
David Riches PSM (2018–19)
Benjamin Rooke (2019)
Andrej Stevanovic (2018–22)
Sally Webster
John Wicks (2017–18)
Nicholas Wolff (2017–19)

Observers
Tarek Barakat (2018–19)
Rene Burkart (2020–21)
Magda Krawiec (2020–21)
Kate Murray (2018)
Jenny Price (2018)
Susan Thompson (2018)

Secretariat
Bianca Tomanovic

CAPITAL CAMPAIGN COMMITTEE
2015–22

Mark Nelson, chair
Geoff Ainsworth AM (2019–20)
Guido Belgiorno-Nettis AM (2015)
Michael Brand
Andrew Cameron AM
S Bruce Dowton
David Gonski AC (2016–22)
Kiera Grant (2020–22)
Kerry-Anne Johnston (2019–21)
Liz Lewin (2021–22)
Justin Miller AM (2019–22)
Gretel Packer AM (2015–21)
Maud Page (2018–22)
John Richardson
Andrew Roberts (2015–19)
Rosie Williams (2019–22)
Peggy Yeoh (2019–22)

PROJECT WORKING GROUP
2017–22

Nicholas Wolff, chair (2017–19)
Sally Webster, chair (2019–22)
Michael Brand
Miranda Carroll (2019–22)
Paul Collis (2019–22)
Clare Eardley (2022)
Hakan Harman (2018–22)
Natasha Henry (2022)
Maud Page
John Richardson (2019–22)
Luke Simkins (2017)
Andrej Stevanovic (2019–22)
Bianca Tomanovic
John Wicks (2017–18)

DESIGN WORKSHOPS – SYDNEY AND TOKYO
2015–17

Art Gallery
Michael Brand
Justin Paton
Suhanya Raffel
Jacquie Riddell
Wayne Tunnicliffe
Sally Webster

Heather Whitely Robertson
Nicholas Wolff

SANAA
Kazuyo Sejima, principal
Ryue Nishizawa, principal
Yumiko Yamada, partner
Asano Yagi, project designer
Soo Kim
Hiroaki Katagiri
Takayuki Hasegawa
Riccardo Cannata
Enrico Armellin
Misha Mikhail Nemkov
Ichio Matsuzawa*
Hana Greer*
(*former staff)

Architectus
Luke Johnson, project principal
Lian Cronje
Nick Elias
John Jeffrey
John Whatmore

McGregor Coxall
Adrian McGregor, project principal
Ann Deng

Arup
Andrew Johnson, project principal
Edward Bond
Nicholas Boulter*
Michaela Brown
Tim Carr
Jake Cherniayeff
Matthew Finn
Marianne Foley
Eve Hoskins*
Nicholas Howard*
Andrew Hulse*
Lisa Kaluzni
Mitsuhiro Kanada
Manuel Lawrence
Elena Longo
Codee Ludbey*
Peter Macdonald
Alistair Morrison
Shane Norton*
Andrew Phillips

Andy Sedgwick
Karen Seeto
Christopher Sims
Paul Sloman
Yuanyuan Song
Harvey Yang
(*former staff)

DESIGN WORKING GROUP
2017–19

Michael Brand, chair
Nicholas Chambers
Clare Eardley
Daniel Griffin
Ujin Lee
Maud Page
Justin Paton
John Richardson
Jacquie Riddell
Luke Simkins
Bianca Tomanovic
Wayne Tunnicliffe
Sally Webster
Heather Whitely Robertson
John Wicks
Nicholas Wolff

OPERATIONAL DELIVERY TEAMS

Art Gallery of New South Wales
Anne Flanagan, project lead (2013–15)
Sally Webster, head (2015–22)
Simone Bird (2015–22)
Alacoque Dash (2022)
Clare Eardley (2017–22)
Gregory Gilet (2017–22)
Daniel Griffin (2018–22)
Denise Knight (2018–22)
Laura Perritt (2020–22)
Phoebe Rathmell (2018–22)
Penny Sanderson (2014–16)
Erika Schneider (2013–17)
Bianca Tomanovic (2016–22)

The Art Gallery recognises the valuable
contribution made by all staff, particularly
members of the Campus Operations
Working Group, in the successful delivery
of the project.

Project directors
John Gale (2013–15)
Andrej Stevanovic (2018–22)
Nicholas Wolff (2015–18)

Infrastructure NSW
Reece Aylmer (2020–21)
Alan Crowe (2021–22)
Sophie Lovett (2020–22)
Claire Mouclier (2020–22)

Richard Crookes Constructions
Phil Irving, project director (2019–22)
Christo Derbyshire (2020–22)
Anthony Di Cecco (2019–22)
Samantha Jones (2019–22)
Anthony Khoury (2020–22)
Luke McClure (2020–22)
Jesse Moss (2019–22)
Paul Notaras (2019–22)
Thomas O'Rourke (2020–22)
Zoran Stepanovksi (2022–22)
Ryan Walters (2020–22)

Precinct Working Group
The Art Gallery recognises the valuable
contribution of precinct colleagues in
particular the Royal Botanic Gardens and
Domain Trust, Transport for NSW and
Airport Motorway Limited.

CAPITAL CAMPAIGN TEAM

Art Gallery of New South Wales
Kirstin Mattson, head (2015–20)
Jessica Block, head (2020–22)
Michela Angeloni (2022)
Brontë Hock (2021–22)
Ivana Jirásek (2017–21)
Denise Knight (2018–22)
Tiffany Leece (2017–22)
Mark Mahony (2015–21)
Emma Rouse (2018–21)
Erika Schneider (2017–18)
Lauren Williams (2022)

ARCHITECTURE TEAMS

SANAA
Kazuyo Sejima, principal
Ryue Nishizawa, principal
Yumiko Yamada, partner
Asano Yagi, project designer
Soo Kim
Hiroaki Katagiri
Takayuki Hasegawa
Riccardo Cannata
Enrico Armellin
Misha Mikhail Nemkov
Ichio Matsuzawa*
Hana Greer*
(*former staff)

Architectus
Ray Brown, CEO
Dr Stephen Long, Public Buildings
Sector lead
Luke Johnson, project principal
Rodd Perey, principal architect
John Jeffrey, design technical lead
John Whatmore, project director
Adriana Alvarez
Andrew Chaplin
Troy Cook
Lian Cronje
Jonathan Dalbert
David Drinkwater
Hope Dryden
Nicholas Elias
Heba El Said
Jane Fielding
Tony Freeman
David Ho
Lewis Jones
Tim Juckes
Anthony Kerr
Sean Lacy
Shawn Li
Samuel Morris
Vatsala Shahi
Manuela Silva
Jennifer Strilakos
Hui Zhu

Donors

We thank the NSW Government and our Sydney Modern Project campaign supporters for their generosity and vision in funding the Art Gallery's expansion.

Lead donor
Susan and Isaac Wakil Foundation

Leadership donors
The Ainsworth Family
Aqualand
The Lee Family
The Lowy Family
The Neilson Foundation
Mark and Louise Nelson
Oranges & Sardines Foundation
Gretel Packer AM

Anonymous
Mark Ainsworth and Family
Valeria and Paul Ainsworth
Guido and Michelle Belgiorno-Nettis
Anita and Luca Belgiorno-Nettis Foundation
The Chen Yet-Sen Family Foundation
 in honour of Daisy Chen
Andrew and Jane Clifford
John Grill AO and Rosie Williams
John and Frances Ingham Foundation
The Medich Foundation
Nelson Meers Foundation
Zareh and Ping Nalbandian
Paradice Foundation
Dr Gene Sherman AM and Brian Sherman AM

Founding donors
Matt Allen AM
David Baffsky AO and Helen Baffsky
Andrew Cameron AM and Cathy Cameron
Rowena Danziger AM and Ken Coles AM
Ian Darling AO and Min Darling
Ashley Dawson-Damer AM
The Douglass Family
Ari, Daniel and David Droga Families
John Gandel AC and Pauline Gandel AC
David Gonski AC and Orli Wargon OAM
The Grant Family
 in memory of Inge Grant

Ginny and Leslie Green
The Hadley Family
The Hua Family
Gary and Kerry-Anne Johnston
Susie Kelly
Elizabeth and Walter Lewin
Paula Liveris and Andrew Liveris AO
Catriona Mordant AM and Simon Mordant AO
Pallion Foundation
Hamish Parker
The Pridham Foundation
Belinda and Bill Pulver
Ruth Ritchie Family Fund
Andrew and Andrea Roberts
Rothwell Family Foundation
Penelope Seidler AM
Charles and Denyse Spice
John and Amber Symond
Will and Jane Vicars
Lang Walker AO and Sue Walker
Philippa Warner
Peter Weiss AO

Major donors
Peter Howarth OAM and Judy Howarth
David Khedoori and Family
Joy Levis, née Wakil
The Lippmann Family
Jillian Segal AO and John Roth
Tee Peng Tay and Family
TLE Electrical
Turnbull Foundation

Visionary donors
Russell and Lucinda Aboud
Antoinette Albert
Geoff Alder
Hayley and James Baillie
Georgina Bathurst and Richard McGrath
Ellen Borda
Drew and Alison Bradford
Jillian Broadbent AC and Rahn Family

Bella and Tim Church
Clitheroe Foundation
Patrick Corrigan AM
Judy Crawford
Anna Dudek and Brad Banducci
Bill Ferris AC and Lea Ferris
Jane Freudenstein AM and Richard
 Freudenstein
Chris and Judy Fullerton
Kerry Gardner AM and Andrew Myer AM
Andrew and Emma Gray
Deborah Gray and Paul Webber
Maurice Green AM and Christina Green
Karen and Michael Gutman
Robert and Lindy Henderson
Sally Herman OAM
Herschell Family
Professor Rina Hui and Edwin Mok
Roslyn and Alex Hunyor
Peter Ivany AO and Sharon Ivany
Ann and Warwick Johnson
Simon Johnson and David Nichols
Dr Patricia Jungfer and Robert C Postema
James Kirby and Claire Wivell Plater
Anne and Mark Lazberger
John Leece AM and Anne Leece
Juliet Lockhart
Amanda and Andrew Love
Michael Martin and Elizabeth Popovski
Fiona Martin-Weber and Tom Hayward
Andrew Michael and Michele Brooks
Justin Miller AM
Alf Moufarrige AO
The Papas Family
The Quick Family
Bill and Karen Robinson
Justine and Damian Roche
Bernard Ryan and Michael Rowe
Edward and Anne Simpson
Rae-ann Sinclair and Nigel Williams
Jenny and Andrew Smith
Allan and Helen Stacey

Colin Tate AM and Matthew Fatches
Georgie and Alastair Taylor
Jane Taylor and Scott Malcolm
Victoria Taylor
Alenka Tindale
Eleonora and Michael Triguboff
Mark Wakely
 in memory of Steven Alward
Barbara Wilby and Christopher Joyce
Ray Wilson OAM
 in memory of James Agapitos OAM
Sharne and David Wolff
Helen Changken Wong
Lily and Su-Ming Wong
Jane and Rob Woods
Bing Wu Family
Carla Zampatti Foundation

Key supporters
AHEPA Daughters of Penelope, Sydney
Deborah and George Antice
Dr Greta DW Archbold
Dr Charles Barnes
Margaret and James Beattie
Peter and Pamela Blacket
Olivia and Jeremy Bond
Camilla Boyd
Peter Braithwaite
Geoff and Jemma Brieger
Vicki Brooke
Karen Florence Byrne
Robert Cameron AO and Paula Cameron
Adam Casselden SC and Iona Borthwick
Arthur Charles AM and Prue Charles
Susan Charlton
Chun-Fa Chen
Jason Chieh-Ching Chen
Matt and Emily Crocker
Elinor Crossing
Dr June Donsworth
 in memory of Michael Hobbs OAM
Blak Douglas

Helen Eager and Christopher Hodges
Suellen and Ron Enestrom
Mark Christopher England and
 Rona Diane Wade AM
Liz and Stewart Ewen OAM
Sandra Forbes
Martyne Ford
Laurence Freedman AM and
 Kathy Freedman AM
Elizabeth Geyer
Katharine Glass
 in memory of Theodora Hobbs
John Head and Leslie Stern
Dr Darryl and Mrs Katherine Hodgkinson
Ivan and Janie Holyman
Vincent Hua
Jonathan and Karen Human
Graham and Sandra Humphrey
Alexandra Joel
Dr Michael Joel AM and Anna Joel
Lesley Kernaghan
Janelle Kidman
The Kidman-Urban Family
Vicki and Adam Liberman
Sarah Mandelson and Richard Single
Peter Mason AM and Kate Mason
Kirstin Mattson and Joerg Raichle
Michael McCorry
Keith, Ben and Mia Miller
Wendy Mostyn Morrison
Multigate Pty Ltd
Dr Clinton Ng
Roslyn Packer AC
Dr Dominic Pak and Cecilia Tsai
Ian and Julie Robertson
Manfred and Linda Salamon
John Samaha and Jo-Ann Smith
Jan and Lyn Shaddock
Vivienne Sharpe
Isabel and David Smithers
Caroline Storch
James Sullivan and Judy Soper

Max and Nola Tegel
Rob Thomas AO
Liz and Simon Thorp
John S Walton AM
Ting-Kung Wei
Professor Ladd Wheeler and
 Helen Wheeler
Shemara Wikramanayake
Family of June and Alan Woods
Sergio Zampatti

NAMED SPACES AT NAALA BADU
The Art Gallery has acknowledged the generous contributions of our leadership and founding donors with naming recognition of spaces at Naala Badu.

Entry level
Susan Wakil Pavilion
Pearl and Ming Tee Lee Plaza and
 Art Garden
Guido and Michelle Belgiorno-Nettis Terrace
Rosie Williams and John Grill Terrace
Ginny and Leslie Green Lifts
Yiribana Gallery founders: The Lowy Family (lead Yiribana founder), Anita Belgiorno-Nettis AM and Luca Belgiorno-Nettis AM, David Baffsky AO and Helen Baffsky, David Gonski AC and Orli Wargon OAM, Gary and Kerry-Anne Johnston, John and Amber Symond, Lang Walker AO and Sue Walker
Pallion Garden Terrace

Lower level 1
Isaac Wakil Gallery
Paradice Foundation Learning Studio
Andrew and Jane Clifford Terrace
Patricia Ritchie Stairs

Building Founders Landing Andrew Cameron AM and Cathy Cameron, Ian Darling AO and Min Darling, The Douglass Family, The Grant Family in memory of Inge Grant, Catriona Mordant AM and Simon Mordant AO, Hamish Parker, The Pridham Foundation, Andrew and Andrea Roberts, Penelope Seidler AM, Charles and Denyse Spice, Will and Jane Vicars

Lower level 2
Ainsworth Family Gallery
Aqualand Atrium
Neilson Family Gallery
Roy and Patricia Medich Sculpture Garden
Nelson Meers Foundation Hall
Hua Family Spirit House Garden
Lewin Media Lab

Lower level 4
Nelson Packer Tank
Rothwell Stairs

Trustees of the Art Gallery of New South Wales 2008–2023

Contributors

Iwan Baan is a Dutch architecture and documentary photographer who works with the world's foremost architects, such as SANAA, Rem Koolhaas, Herzog & de Meuron, Zaha Hadid, Diller Scofidio & Renfro, and Toyo Ito. Alongside his commissions, Baan has collaborated on several successful book projects. Named one of the 100 most influential people in contemporary architecture in 2011, Baan is a recipient of the AIANY Stephen A Kliment Oculus Award.

Eve Blau is an American architectural historian and critic. She is adjunct professor of the history and theory of urban form and design at the Graduate School of Design at Harvard University, where she is also director of the Davis Center for Russian and Eurasian Studies and co-director of the Harvard Mellon Urban Initiative. She has written extensively on the intersections between art, media, architecture and urbanism, with a particular emphasis on the social, political, and economic factors that shape built environments.

Michael Brand is the director of the Art Gallery of New South Wales, where he has led the transformation and expansion of the institution through the Sydney Modern Project. Prior to his appointment at the Art Gallery in 2012, he was the director of the Aga Khan Museum in Toronto, the J Paul Getty Museum in Los Angeles, and the Virginia Museum of Fine Arts in Richmond. Brand is a scholar of Indian and Islamic art, architecture and landscape, and is recognised as a prominent voice in the global conversation about the future of art museums.

Anthony Burke is a professor of architecture at the University of Technology Sydney with twenty-five years' experience in lecturing, publishing, exhibiting and celebrating the value of good design and architecture around the world. He is the presenter of the ABC TV programs *Restoration Australia* and *Grand Designs Transformations*, and was a creative director for the Australian Pavilion at the Venice Architecture Biennale in 2012.

Yuko Hasegawa is a Tokyo-based curator, art critic, and honorary professor at the Graduate School of Global Arts, Tokyo University of the Arts. She is the director of the 21st Century Museum of Contemporary Art, Kanazawa, and artistic director of the Inujima Art House Project. She has written numerous books and papers, with her recent work exploring notions of ecology and placemaking. Her awards include Chevalier de l'Ordre des Arts et des Lettres and the Japan Commissioner for Cultural Affairs Award.

Juhani Pallasmaa is a distinguished architect and professor emeritus based in Helsinki. His previous positions include rector of the Institute of Design, Helsinki; director of the Museum of Finnish Architecture; and professor and dean of the Faculty of Architecture, Aalto University. He is the author of 70 books on architecture, including *The eyes of the skin: architecture and the senses*, which has become a classic in the field. Pallasmaa was a member of the Pritzker Architecture Prize Jury from 2008 to 2014. He was on the jury of the Sydney Modern Project design competition in 2015.

Kazuyo Sejima and Ryue Nishizawa founded the architectural firm SANAA in 1995 and have since designed a number of award-winning buildings around the world, including the 21st Century Museum of Contemporary Art in Kanazawa and Grace Farms in Connecticut. In 2010, they were awarded the Pritzker Architecture Prize. SANAA creates spaces that bring people together through openness and lightness.

Sally Webster is the director of program delivery at the Art Gallery of New South Wales. She served as the head of the Sydney Modern Project, managing the institution's major expansion project from the completion of the international design competition in 2015 to 2023. Prior to joining the Art Gallery, she held project and curatorial roles with Arts NSW and the Historic Houses Trust of NSW where she managed arts and cultural development projects as well as developed and delivered exhibitions.

Image credits

All photographs © Iwan Baan, with exceptions listed below.

All artworks are from the collection of the Art Gallery of New South Wales, unless otherwise stated.

p 10
Photo © Hugh Stewart

pp 16, 38, 41, 45, 49, 85, 133
Jonathan Jones *bíal gwiyúŋo (the fire is not yet lighted)* 2024, developed in consultation with Aunty Julie Freeman, Uncle Charles Madden and Oliver Costello, designed and created in collaboration with DCG Design, kangaroo grass (*Themeda triandra*), gadi/grass tree (*Xanthorrhoea*), banksia (*Banksia serrata*), sandstone, bronze, light, cultural fire and cultural programs, dimensions variable, commissioned by the Art Gallery of New South Wales on Gadigal Country with support from cultural programming founders Zareh and Ping Nalbandian, Philippa Warner, and Susie Kelly, design and construction support from the Art Gallery of New South Wales Foundation, and Geoff Ainsworth AM and Johanna Featherstone, and support from early cultural programming donors the Anita and Luca Belgiorno-Nettis Foundation, Gretel Packer AM, Anne and Mark Lazberger, and Justine and Damian Roche © Jonathan Jones

p 24
Photo © Art Gallery of New South Wales, Craig Willoughby

p 26
Photo © Art Gallery of New South Wales, Jenni Carter

p 27
From top: photo: Hisao Suzuki; photo: Asano Yagi

p 28
Photo © Art Gallery of New South Wales, Jenni Carter

p 32
Photo © Art Gallery of New South Wales, Sahlan Hayes

p 33
Artworks courtesy and © The Easton Foundation/VAGA at ARS/ Copyright Agency, 2024, photo © Art Gallery of New South Wales, Felicity Jenkins

pp 34–35
Lee Mingwei 李明維 *Spirit House* 光之屋 2022, bronze, concrete, rattan-wrapped stones, rammed earth, timber, lighting, glass oculus, dimensions variable, commissioned with funds provided by The Chen Yet-Sen Family Foundation in honour of Daisy Chen 陳范俪瀞 陈范俪瀞 and the Art Gallery of New South Wales Foundation 2022 © Lee Mingwei, photo © Art Gallery of New South Wales, Wei-Lung Lin

pp 38, 41, 42, 54, 61, 63, 67, 68–9, 71, 78, 152, 153, 72, 178–79, 193
Yayoi Kusama *Flowers that Bloom in the Cosmos* 2022, stainless steel, polyurethane paint, dimensions variable, commissioned with funds provided by the Art Gallery of New South Wales Foundation and the Gandel Foundation 2022 © Yayoi Kusama

pp 49, 52–3, 83, 85, 95, 148, 175
Francis Upritchard *Here Comes Everybody* 2022, three cast bronze sculptures with patina dimensions variable, commissioned with funds provided by Peter Weiss AO, the Droga Family in memory of Vibeke Droga, the Hadley Family, and the Art Gallery of New South Wales Foundation 2022 © Francis Upritchard

pp 74, 102, 105, 107, 122–23
Takashi Murakami *Japan Supernatural: Vertiginous After Staring at the Empty World Too Intensely, I Found Myself Trapped in the Realm of Lurking Ghosts and Monsters* 2019, acrylic, gold leaf and glitter on canvas, 300 x 1000 cm, purchased with funds provided by the Art Gallery of New South Wales Foundation 2019 © 2019 Takashi Murakami/Kaikai Kiki Co., Ltd. All Rights Reserved.

pp 74, 142–43
Richard Lewer *Onsite, construction of Sydney Modern which resides on the lands of the Gadigal of the Eora Nation* 2020–21, painting: oil on nine aluminium panels, 153 x 729 cm overall; fourteen drawings: archival ink marker pen on museum rag board, 37 x 29 cm each commissioned with funds provided by the Art Gallery of New South Wales Foundation 2021 © Richard Lewer

p 77
Inujima Art House Project, A-Art House, featuring Haruka Kojin's installation *reflectwo* 2013, artwork © Haruka Kojin, courtesy SCAI The Bathhouse, Tokyo, photo © Kazuyo Sejima & Associates

p 84
From top: Howie Tsui *Retainers of Anarchy* 2018, algorithmic animation sequence, five-channel video projection, six-channel audio, 340 cm x 2418 cm, purchased with funds provided by the Asian Art Collection Benefactors 2018 © Howie Tsui, photo © Art Gallery of New South Wales, Zan Wimberley

pp 84, 178–79
Kimsooja *Archive of mind* 2016–ongoing, participatory installation with clay, wooden table and stools; *Unfolding sphere* 16-channel sound performance, 15:28 min, display dimensions variable, purchased with funds provided by the Art Gallery of New South Wales Foundation 2018 © Kimsooja, photo © Art Gallery of New South Wales, Christopher Snee

pp 85, 95
Lorraine Connelly-Northey *Narrbong-galang (many bags)* 2022, metal, display dimensions variable, commissioned with funds provided by the Art Gallery of New South Wales Foundation 2022 © Lorraine Connelly-Northey

p 86
Photo © Shinkenchiku-sha

p 87
Adrián Villar Rojas *The End of Imagination IV* 2022, mixed media, 323 x 310 x 250 cm overall, purchased 2023 with funds provided by the 2016 Art Gallery of New South Wales Foundation gala dinner, Kerr Neilson and the Mervyn Horton Bequest Fund with additional support from Greg Peirce © Adrián Villar Rojas, photo © Jörg Baumann

pp 97, 98, 101
John Olsen *Spanish encounter* 1960, oil on composition board, 183 x 366 cm, purchased 1960 © Art Gallery of New South Wales

pp 96–7, 120–21, 130
Lisa Reihana *GROUNDLOOP* 2022, single-channel digital video with multi-layered audio, aspect ratio: 256:63, 21 min, commissioned with funds provided by the Art Gallery of New South Wales Foundation, Creative New Zealand and the following visionary donors: Anna Dudek and Brad Banducci, Simon Johnson and David Nichols, Michael Martin and Elizabeth Popovski, The Papas Family, Bill and Karen Robinson, Rae-ann Sinclair and Nigel Williams, and Jenny and Andrew Smith 2022 © Lisa Reihana

pp 108–09
Ernesto Neto *Just like drops in time, nothing* 2002, polymer stretch fabric, spices, display dimensions variable, purchased with assistance from Clayton Utz 2002 © Ernesto Neto

pp 110–11
From left: Nina Abney *2 STEP* 2021, 5 panels, acrylic and spray paint on canvas, 213.4 x 762 cm, purchased with funds provided by Andy Song and the Mollie and Jim Gowing Bequest 2021 © Nina Chanel Abney

Mira Gojak *Pausing place, uncounted* 2019, steel and yarn, 380 x 250 x 150 cm, purchased with funds provided by the Contemporary Collection Benefactors 2019 © Mira Gojak

Gail Mabo *Tagai* 2020, bamboo, cotton, shellac and plastic, 287 x 290 x 15 cm (approx), purchased with funds provided by Vicki Olsson 2020 © Gail Mabo/Copyright Agency, 2024

p 112–13
Michael Parekōwhai *Te Ao Hau* 2022, glass, copper, LED lights, automotive paint on wood, fibreglass, aluminium, steel, acrylic, 237.2 × 615.1 × 318 cm, commissioned 2022 for the *Dreamhome: Stories of Art and Shelter* exhibition with the support of Tony Kerridge and Micheal Do. Additional support from Michael Lett and Andrew Thomas, collection of the artist © Michael Parekōwhai/Michael Lett Gallery

pp 114, 121
Betty Kuntiwa Pumani *Antara* 2017, acrylic on linen, 203 x 303 cm, acquired with funds provided by the Art Gallery of New South Wales Board of Trustees 2017 © Betty Kuntiwa Pumani

p 115, 130
Lindy Lee *Zip zero zilch* 1995, synthetic polymer paint, oil, wax on hardboard, 205 x 142.5 cm, gift of Sue Griffin 2009 © Lindy Lee/ Copyright Agency, 2024

p 115
Gemma Smith *Zero* 2016, acrylic on linen, 185 x 185 cm, purchased with funds provided by the Contemporary Collection Benefactors 2020 © Gemma Smith

Sculptures from the series *Pack of ku'* 2021–22, natural pigments with binders on milkwood, dimensions variable, commissioned with funds provided by the Aboriginal Art Collection Benefactors 2021 © the artists

p 126
From left: Yhonnie Scarce *Death zephyr* 2017, hand-blown glass, nylon and steel, dimensions variable, purchased with funds provided by the Aboriginal Art Collection Benefactors 2017 © Yhonnie Scarce

Ronnie Tjampitjinpa *Tingari fire dreaming at Wilkinkarra* 2008, synthetic polymer paint on linen, 244 x 181.4 cm, Wendy Barron Bequest Fund 2014 © Ronnie Tjampitjinpa. Licensed by Aboriginal Artists Agency Ltd

Willy Tjungurrayi *Tingari story* 1986, synthetic polymer paint on linen, 242.5 x 362.5 cm, Mollie Gowing Acquisition Fund for Contemporary Aboriginal Art 1993 © Willy Tjungurrayi. Licensed Aboriginal Artists Agency Ltd, photo © Art Gallery of New South Wales, Felicity Jenkins

p 129
Photo © SANAA

p 130
Stanley Whitney *Just like Ornette* 2010, oil on linen, 244 x 244 cm, John Kaldor Family Collection © Stanley Whitney

p 136
Photo © Art Gallery of New South Wales, Craig Willoughby

p 137
Photo © Art Gallery of New South Wales, Felicity Jenkins

p 139
Photos © Rory Gardiner

pp 140, 141
Photos © Art Gallery of New South Wales

pp 166–67
From left: Justene Williams *Boccioni babe* 2022, bronze, silver metallic epoxy paint, 220 x 190 x 75 cm, purchased 2022 © Justene Williams

Sanné Mestrom *The offering (nyotaimori reclining nude)* 2021, concrete and bronze, dimensions variable, purchased with funds provided by the Barbara Tribe Bequest 2022 © Sanné Mestrom

p 186
Photos © Art Gallery of New South Wales

p 187
Photo © Brett Boardman

pp 188–89
Photos © Art Gallery of New South Wales

p 190
Photos © Art Gallery of New South Wales

p 192
Photos © Brett Boardman

p 194
Top: Photo: Asano Yagi

p 195
Photo © Art Gallery of New South Wales, Craig Willoughby

pp 198–207
All architectural floorplans and elevations © Kazuyo Sejima + Ryue Nishizawa / SANAA

Published by Art Gallery of New South Wales
on Gadigal Country
Art Gallery Road, The Domain
Sydney 2000, Australia
artgallery.nsw.gov.au
© 2024 Art Gallery of New South Wales

A catalogue record for this book is available from the
National Library of Australia website at nla.gov.au
ISBN 978 1 74174 157 5

Managing editor: Faith Chisholm
Text editor: Linda Michael
Text contributor: Denise Knight
Design: Dominic Hofstede (Mucho)
Rights & permissions: Megan Young
Photography: Iwan Baan; additional photographers
indicated in image credits list
Proofreader: Kay Campbell, The Comma Institute
Production: Cara Hickman
Prepress: Spitting Image, Sydney
Printing: Printed in China by Australian Book Connection

The Art Gallery of New South Wales is a statutory
body of the NSW Government

Distribution:
Thames & Hudson Australia
Thames & Hudson UK
University of Washington Press USA

Cover: Aerial view of Naala Badu, July 2024.
Photo: © Iwan Baan